WASSILY KANDINSKY

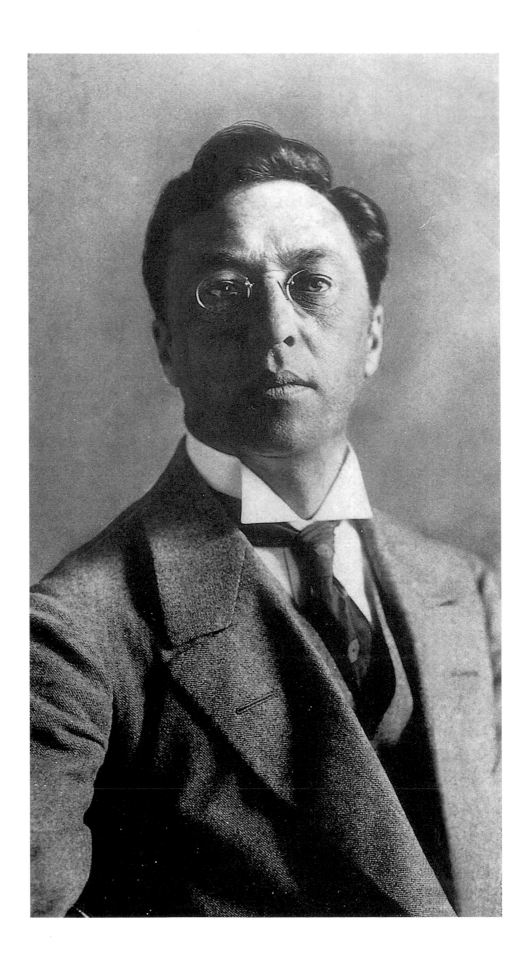

Portrait of Kandinsky, c. 1913
Photograph
accompanying his autobiographical *Reminiscences*, 1913

Ulrike Becks-Malorny

WASSILY KANDINSKY

1866–1944

The journey to abstraction

TASCHEN

KÖLN LONDON MADRID NEW YORK PARIS TOKYO

© 1999 Benedikt Taschen Verlag GmbH
Hohenzollernring 53, D–50672 Köln
© 1999 for the illustrations: VG Bild-Kunst, Bonn
Cover design: Angelika Taschen, Cologne
English translation: Karen Williams, Low Barns

Printed in Singapore
ISBN 3–8228–7079–X

Contents

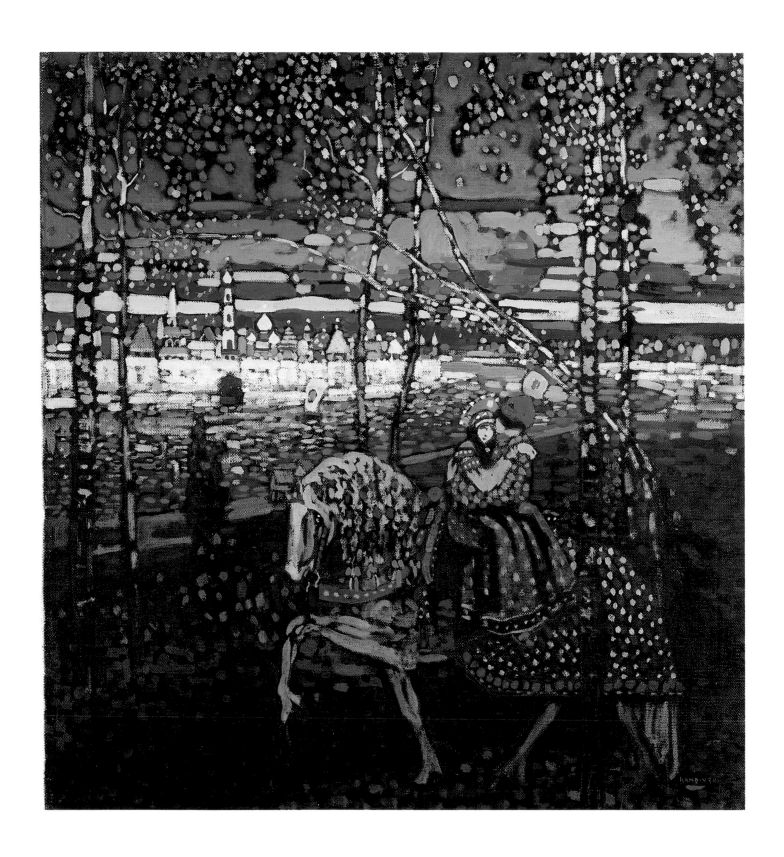

Beginnings in Munich

"A man who can move mountains." Thus Franz Marc described his friend and colleague Wassily Kandinsky, who revolutionized the art of our century with his ideas of a new pictorial language.

For as the founder of abstract painting Kandinsky released art from its traditional duty – namely, to provide a copy of the visible world. Although, in the early years of the twentieth century, there were other artists similarly experimenting with the dissolution of the object and the promotion of colour and form to means of expression in their own right, Kandinsky was the most logical and consistent in his pursuit of abstract means of expression. He made it his life's work to carry painting up to and over the threshhold of abstraction, whereby his artistic activities were always accompanied by theoretical reflections and insights.

Music, as a form of art free from all obligation to the outside world, thereby provided him with both a point of orientation and a yardstick in his observations on the "sounds" of colours. Kandinsky envied music its independence and the freedom of its means of expression, and he attempted to establish what he called a "theory of harmony for painting" comparable to that of music – an internal discipline which colours and forms were to obey.

All his life Kandinsky was a traveller between worlds. Born in Moscow in 1866, he spent the majority of his years in Germany and Paris. Yet he was Russian through and through. He viewed his beloved Moscow as the quintessence of everything Russian and the inspiration for all his artistic endeavours. The powerful emotions and intense impression of colour which swept over him at the sight of the roofs and onion domes of Moscow bathed in the evening light awoke in him the desire to capture the experience on canvas. The colour harmonies of the magical cityscape struck him like the sounds of different instruments and shook him to the depths of his soul:

"The sun dissolves the whole of Moscow into a single spot, which, like a wild tuba, set all one's soul vibrating... Pink, lilac, yellow, white, blue, pistachio green, flame red houses, churches, each an independent song – the garish green of the grass, the deeper tremolo of the trees, the singing snow with its thousand voices, or the *allegretto* of the bare branches, the red, stiff, silent ring of the Kremlin walls, and above, towering over everything, like a shout of triumph, like a self-oblivious hallelujah, the long, white, graceful, serious line of the Bell Tower of Ivan the Great..."

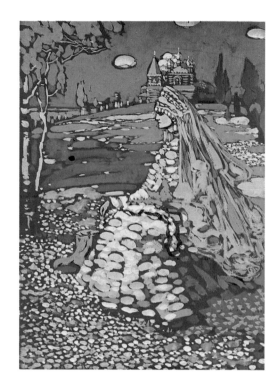

Russian Beauty in a Landscape, c. 1904
Russische Schöne in Landschaft
Tempera, card, lined in dark grey,
41.5 x 28.8 cm
Munich, Städtische Galerie im Lenbachhaus

PAGE 6:
Couple Riding, 1906/07
Reitendes Paar
Oil on canvas, 55 x 50.5 cm
Munich, Städtische Galerie im Lenbachhaus

In the "romantic" pictures of his early Munich years Kandinsky returns to the magical Moscow of his childhood memories. His subjects are taken from the world of chivalrous knights and ancient legend. *Couple Riding* is a scene from an old Russian fairytale: the Knight bears home the beautiful Helena, whom he has just rescued from the clutches of the firebird. Kandinsky's costly, shimmering palette and impressionistic application of paint lend these pictures a poetic, symbolic character.

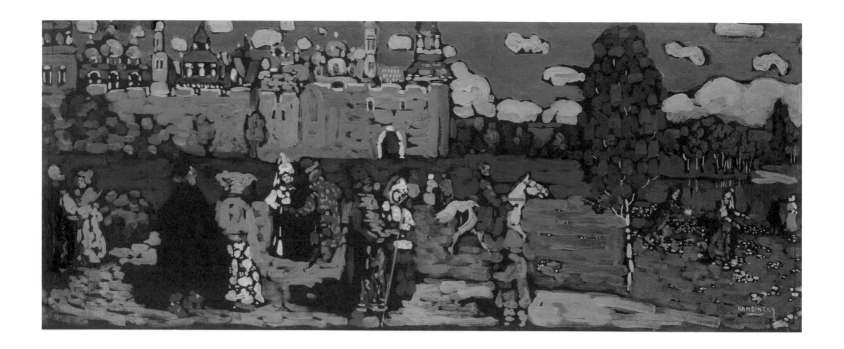

Russian Scene, 1904
Russische Szene
Tempera on card, 23 x 55 cm
Paris, Musée National d'Art Moderne,
Centre Georges Pompidou

This is not a picture of Russian life at the begin-
ning of the century, but an atmospheric folkloric
scene in which the originality and the magic of
Russian legends come to the fore. Kandinsky
produced a number of tempera paintings with
motifs of "Old Russia" while staying in Sèvres,
near Paris, where Russian art and music were
currently in great vogue.

PAGE 9 ABOVE:
Volga Song, 1906
Wolgalied
Tempera on card, 49 x 66 cm
Paris, Musée National d'Art Moderne,
Centre Georges Pompidou

PAGE 9 BELOW:
Colourful Life, 1907
Das bunte Leben
Tempera on canvas, 130 x 162.5 cm
Munich, Städtische Galerie im Lenbachhaus

To paint this hour, I thought, must be for an artist the most impossible,
the greatest joy."

The young Kandinsky lacked the confidence to embark upon an art-
istic career straight away, however. He saw art as something exalted and
unattainable, and considered his own abilities still too inadequate to be
able to express his feelings in pictures. Instead he did a degree in law,
combined with courses in economics, graduating at the age of 26. Yet
art, whether in the form of painting or music, continued to prove itself a
source of new and surprising insights. Visiting the Hermitage in St. Pe-
tersburg, he was fascinated by the division of Rembrandt's paintings into
areas of light and dark and discovered a "mighty chord" in the contrasts
between their colours. Wagner's music provided him with his first experi-
ence of a total work of art. At a performance of *Lohengrin,* the sounds of
the orchestra conjured up before his eyes the colours of a Moscow eve-
ning; he saw and heard the sunset hour he so longed to paint and real-
ized that painting could develop just such powers as music possesses.
Kandinsky had a particular capacity for synaesthetic experience. He did
not perceive colours solely in terms of objects, but associated them with
sounds which ranged in varying intensities from high to low and shrill to
muted.

Another profound experience occurred in Kandinsky's final year as a
law student in Moscow, when he saw a painting from Monet's *Haystacks*
series and – disconcertingly – failed to recognize the subject. This gave
him a first inkling that the power of colour could render the presence of
the object superfluous. Long before Kandinsky addressed himself syste-
matically to painting and focused his attention upon the problem of non-
objectivity in the picture, he unconsciously realized from this Impressio-
nist work that the force of the palette alone can determine the impact of a
picture. When he eventually came to renounce the object in his own art,
he would remember that fateful encounter with Monet.

In the light of these formative experiences, Kandinsky's decision to

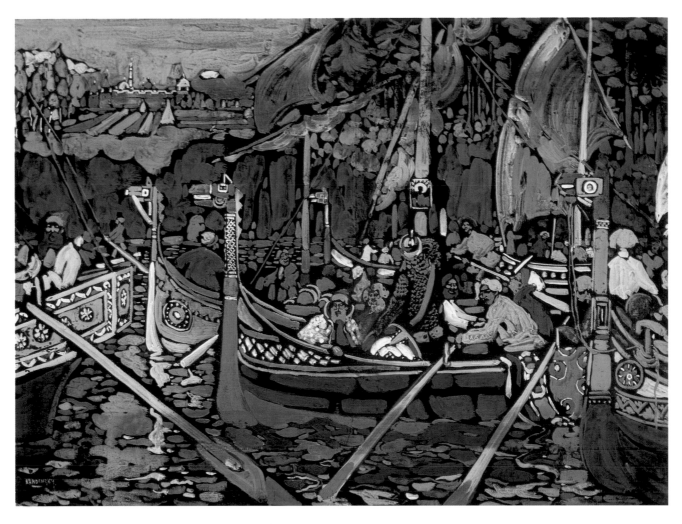

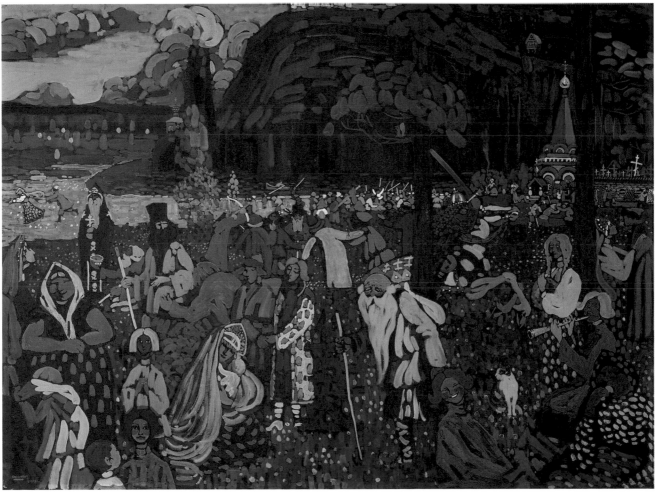

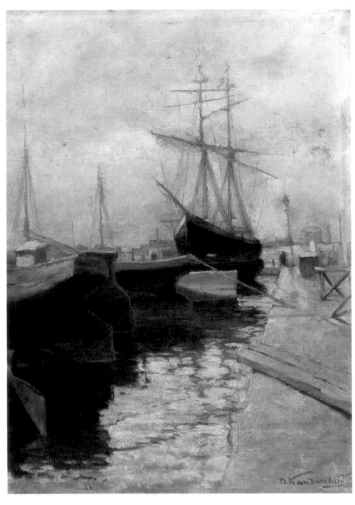

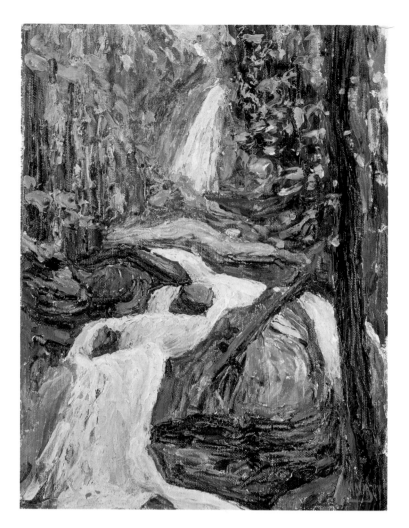

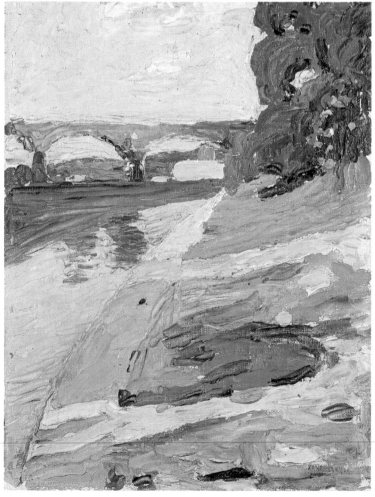

ABOVE LEFT:
Odessa – Port I, c. 1898
Odessa – Hafen I
Oil on canvas, 65 x 45 cm
Moscow, State Tretyakov Gallery

ABOVE RIGHT:
Kochel – Waterfall I, c. 1900
Kochel – Wasserfall I
Oil on canvas, 32.4 x 23.5 cm
Munich, Städtische Galerie im Lenbachhaus

RIGHT:
The Isar near Grosshesselohe, 1901
Die Isar bei Großhesselohe
Oil on canvas, 32.5 x 23.6 cm
Munich, Städtische Galerie im Lenbachhaus

Half realist, half Impressionist – Kandinsky's first oil paintings are
tentative attempts to find a personal form of expression. Colour al-
ready plays a dominant role, forcing the object into second place.
Kandinsky uses the palette knife to apply his paints in impastoed
strips, making them "sing out" as powerfully as he can.

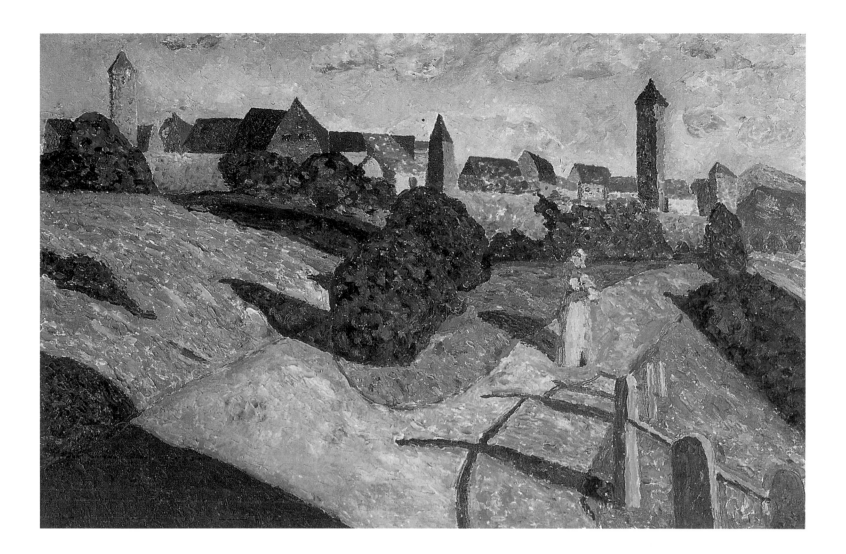

become a painter is not altogether surprising. By the time he left Moscow for Munich in 1896, he was no longer working as a lawyer, but as the director of a printing works specializing in art reproductions. It seems he had already abandoned the academic legal path for good.

Kandinsky was 30 when he went to Munich. Since the days of Ludwig I, the city on the Isar had enjoyed a reputation as a flourishing centre of the arts. It was there that Arnold Böcklin and Franz von Stuck celebrated their greatest triumphs, and there that the Munich Secession was founded in 1892, giving a platform to a group of progressive artists. The Secession embraced a wide spectrum of stylistic trends, ranging from academic historicism and naturalism to Impressionism and Symbolism. The artists of the Secession may have lacked a common programme, but they nevertheless managed to break away from the encrusted traditions of Academy exhibitions and brought a breath of fresh air into the Munich art scene.

Another contemporary movement rising to prominence in Munich was Jugendstil. Originating from the Arts and Crafts Movement in England, and the German counterpart to Art Nouveau in France and Belgium, Jugendstil took its name from the journal *Jugend (Youth)* founded in Munich in 1896. Jugendstil aimed to create a new consciousness of form which would replace the pomposity and obsessive detail of 19th-century historicism. Typical features of this new style included the use of power-

Old Town II, 1902
Alte Stadt II
Oil on canvas, 52 x 78.5 cm
Paris, Musée National d'Art Moderne,
Centre Georges Pompidou

"On good advice, I visited Rothenburg ob der Tauber… Only one picture has survived from this trip, *The Old Town*, which I painted from memory only after my return to Munich. It is sunny, and I made the roofs just as bright a red as I then knew how."
(Kandinsky in *Reminiscences*, 1913)

11

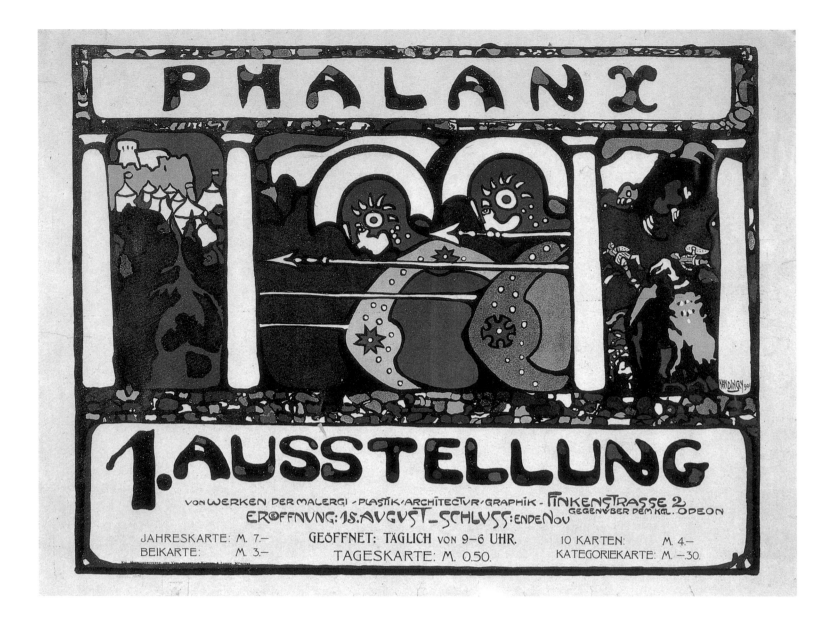

Poster for the 1. Phalanx Exhibition, 1901
Colour lithograph on paper, 47.3 x 60.3 cm
Munich, Städtische Galerie im Lenbachhaus

Phalanx was an association of artists founded by Kandinsky in 1901. Its aim was to provide an exhibition platform for artists who were underrepresented in the official Munich art-dealing world. There were eleven Phalanx exhibitions altogether. Kandinsky was interested above all in publicizing works by the French Impressionists and Neo-Impressionists. He particularly admired Claude Monet, one of whose *Haystacks* series he had earlier seen in Moscow.

ful undulating lines and decorative ornament entirely abstracted from the representational world. The spokesmen for the reformist movement were the young architect August Endell and the sculptor Hermann Obrist. Endell's designs for the Elvira Hofatelier of 1896/97 (p. 12) caused a scandal in Munich, and his provocative thesis that "The greatest mistake one can make is to believe that Art is the reproduction of Nature" was perceived as an affront to the Munich art establishment.

Kandinsky arrived in Munich in 1896 accompanied by his young wife, his cousin Anya Chimikian whom he had married in 1892. He began his studies at the well-known art school run by the Yugoslav Anton Ažbè, where his initial enthusiasm was rapidly dampened by the life classes; drawing "smelly, apathetic, expressionless, characterless" models was something he found thoroughly repellent. He took the life class for two years nevertheless, but used every spare opportunity to paint vibrantly coloured landscape studies from nature. Such works led his fellow students to classify him as a "colourist" and a "landscape painter", labels which pained him, even though he admitted himself that he was much more at home with colour than with drawing. "I was intoxicated with nature," he later wrote, "again and again I tried to make colour carry first the chief

weight and subsequently the entire weight." Seeking to improve his drawing skills, he applied to join the class run by Academy professor Franz von Stuck, co-founder of the Munich Secession, who was at that time considered to be Germany's foremost draughtsman. This first application was rejected, but after a year of working on his own Kandinsky applied again, and this time was accepted into Stuck's painting class. Stuck praised Kandinsky's expressive drawings, but opposed his "extravagant use of colour" and advised him to spend a while working exclusively in black and white "so as to study form by itself". A lingering echo of Stuck's recommendations can perhaps be found in Kandinsky's later woodcuts and his colour drawings on a black ground. Kandinsky attended Stuck's classes for a year and benefitted in several ways from his teacher. "He cured my pernicious inability to finish a picture with one single utterance. He told me I worked too nervously, that I singled out the interesting bit straight away." Stuck taught him how to integrate his spontaneous creative ideas into the more routine aspects of the overall composition.

When Kandinsky left Stuck's atelier in the late autumn of 1900 he had been living in Munich for four years. We have almost no tangible evidence of his artistic activities during this period, however: apart from a few furniture designs in sketchbooks, no works have survived. Kandinsky had nevertheless learned much about the mechanics of exhibiting in the Bavarian capital, and had no doubt recognized how difficult it was to make a name for oneself as an artist within such a talented field of competition.

The founding of the artists' association Phalanx in May 1901 offered Kandinsky the opportunity not only to take part in exhibitions himself, but – even more importantly – to introduce the public to trends in art which were still underrepresented in Munich, namely Impressionism and Jugendstil. The members of Phalanx had met through Stuck's atelier and included, alongside Kandinsky, Stuck's studio assistant Ernst Stern, the puppeteer Waldemar Hecker and the sculptor Wilhelm Hüsgen. These last three were members of "Die Elf Scharfrichter" (The Eleven Executioners), a literary and artistic cabaret which, like Phalanx, rejected traditional artistic conventions and championed the ideals of the avant-garde. Kandinsky was particularly fascinated by one of the numbers performed in the cabaret, in which the artist Stern produced "musical drawings" by moving his pencil across a piece of paper to the rhythm of a piece of music.

Kandinsky designed the poster for the first Phalanx Exhibition (p. 14). Although clearly inspired by an earlier poster by Franz von Stuck advertising the Munich Secession exhibition of 1893 (p. 15 above), it goes much further in its use of flat areas of colour and its degree of abstraction. Its forms are also more dynamic, as Kandinsky presents the phalanx of the avant-garde attacking the fortress of tradition.

The first Phalanx exhibition included unidentified works by Kandinsky, puppets and masks from the "Scharfrichter" cabaret, and a selection of decorative pieces. It was the first time that Kandinsky had stepped into the public arena, and it was clear from the start that he was eager to draw upon many different artistic trends in support of his aims. Phalanx also gave him his first opportunity to act as leader of a group of kindred spirits. In the Phalanx School of Painting founded soon afterwards he was also to reveal his talents as a teacher. Indeed, organization and teach-

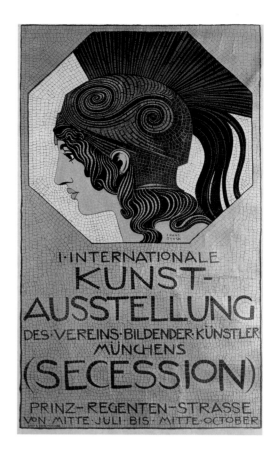

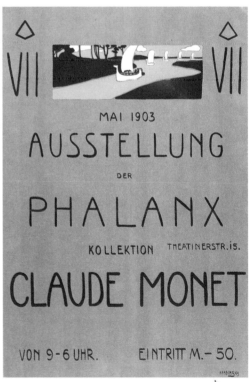

ABOVE:
Franz von Stuck:
Poster for the International Art Exhibition held by the Munich Secession in 1893
Lithograph on paper, 61.5 x 36.5 cm
Munich, Münchner Stadtmuseum

BELOW:
Poster for the 7. Phalanx Exhibition, 1903
Colour lithograph on paper, 83.5 x 61.2 cm
Munich, Städtische Galerie im Lenbachhaus

15

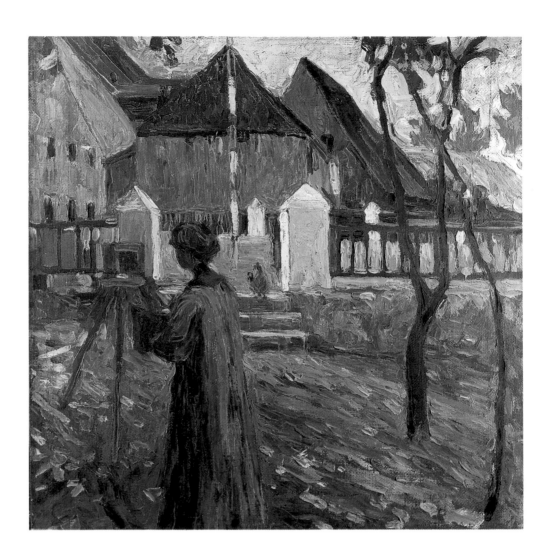

Gabriele Münter Painting in Kallmünz, 1903
Gabriele Münter beim Malen in Kallmünz
Oil on canvas, 58.5 x 58.5 cm
Munich, Städtische Galerie im Lenbachhaus

Kandinsky and Gabriele Münter in Kochel, 1902
Photograph
Munich, Gabriele Münter and Johannes Eichner
Foundation

ing were to become the main strands which would run alongside Kandinsky's artistic activities throughout his life. He was never solely a painter, but a theoretician, intermediary and organizer at the same time.

The Phalanx School of Painting was forced to close after just a year due to lack of students, but by then it had introduced Kandinsky to Gabriele Münter, who had registered as a pupil. Gabriele Münter became the intimate companion of Kandinsky's Munich years. As his confidante and critic, she partnered him through the crucial years of his artistic development, although she was ultimately unable to follow his path to abstraction in her own painting.

In 1903 Kandinsky began a series of extensive trips abroad, frequently in the company of his new companion. He had separated from his wife Anya and given up the apartment they had shared in Munich. His travels took him to Venice, Odessa, Tunis, Rapallo, Paris, Berlin and the South Tyrol. Some of these destinations probably coincided with exhibitions in which he was taking part; he regularly submitted works to the Berlin Secession and the Salon d'Automne in Paris, for example. This was also a period of exploration and experimentation with new means of artistic expression. The works which he produced between 1900 and 1908 are correspondingly unhomogeneous in nature, and as yet give no hint of the transformations that Murnau would bring.

A generous share of this early œuvre is made up of works in tempera in

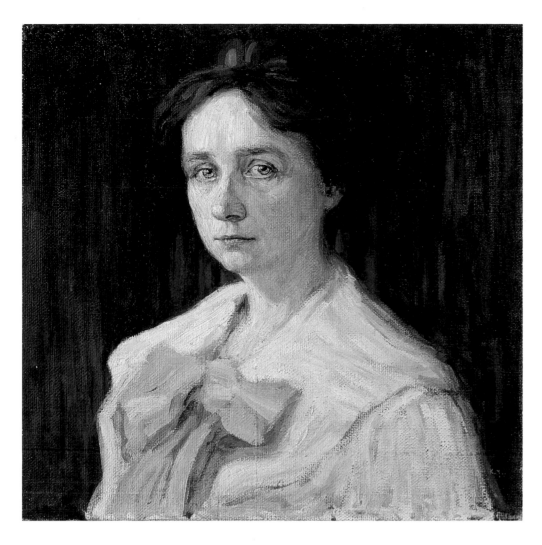

Gabriele Münter was one of the first women students at the Phalanx school, at which Kandinsky taught painting and life drawing. State art academies were still closed to women at that time. The pupil-teacher relationship developed into an intimate bond, and Gabriele Münter remained Kandinsky's companion until 1914.

"You are hopeless as a pupil," Kandinsky told Gabriele Münter. "One can't teach you anything. You can only do what is inside you. You have everything naturally. What I can do for you is protect and nurture your talent so that nothing comes to spoil it."

Portrait of Gabriele Münter, 1905
Bildnis von Gabriele Münter
Oil on canvas, 45 x 45 cm
Munich, Städtische Galerie im Lenbachhaus

which Kandinsky takes up themes from Russian folksong and legend. *Russian Beauty in a Landscape* (p.7), painted around 1904, is a creation of Kandinsky's rhapsodic imagination. Against a dark background, a fairytale figure is seated within a fairytale landscape shimmering in a kaleidoscope of colours. Small dabs of paint build a mosaic-like surface and suggest a dream world lost in time and space. *Russian Scene* (p.8) and *Volga Song* (p.9 above) also appear to be taken from Russian folklore. For Kandinsky, these pictures were an expression of his homesickness for Russia: "In my use of line and distribution of coloured dots, I was trying to express the musical side of Russia. Other pictures from that period reflect the contradictory, later the eccentric aspects of Russia."

The large-format tempera *Colourful Life* (p.9 below) equally belongs to the mythically transfigured world of fairytale. Here, however, the figures of romantic folklore have given way to a crowded wealth of characters and activities from secular and sacred Russian life. More than in other works from the same period, human figures have here become abstract colour ornaments. Kandinsky is perhaps recalling his impressions of a research trip to the province of Vologda, where the peasants in their colourful local costumes "ran around like brightly coloured, living pictures on two legs", and where he was profoundly struck by the "great wooden houses covered with carvings" and the "brightly coloured, elaborate ornaments" decorating every item of furniture and every object.

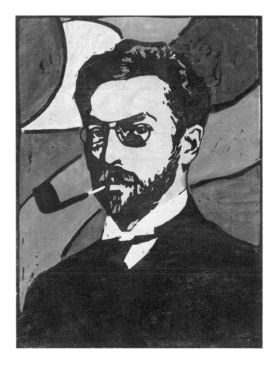

Gabriele Münter:
Portrait of Kandinsky, 1906
Porträt Kandinsky
Colour woodcut, 25.9 x 19 cm
Munich, Städtische Galerie im Lenbachhaus

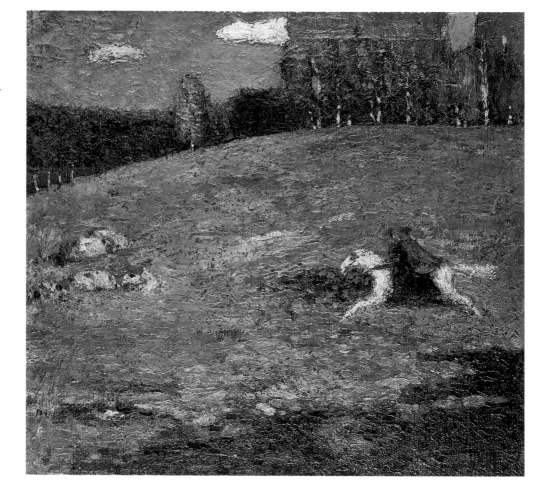

The Blue Rider, 1903
Der blaue Reiter
Oil on canvas, 55 x 65 cm
Zurich, private collection

The rider is a romantic fairytale figure from Kandinsky's Russian childhood. As Saint George, he combats evil and symbolizes battle and setting forth upon new adventures.

BELOW:
Untitled (Knight and Dragon), c. 1903/04
Ohne Titel (Ritter und Drache)
Pencil on paper
Munich, Städtische Galerie im Lenbachhaus

PAGE 19, ABOVE LEFT:
The Singer, 1903
Die Sängerin
Colour woodcut, three blocks, second state, 19.5 x 14.5 cm
Munich, Städtische Galerie im Lenbachhaus
PAGE 19, BELOW:
The Golden Sail, 1903
Das goldene Segel
Colour woodcut, two blocks, gold and stencil, third state, 12.7 x 29.7 cm
Munich, Städtische Galerie im Lenbachhaus

PAGE 21:
In the Forest, 1904
Im Walde
Mixed media on panel, 26 x 19.8 cm
Munich, Städtische Galerie im Lenbachhaus

Singer is thus intended as a synthesis of sound, image and word. We are shown the precise moment at which the pianist plays the first notes and the singer starts to sing – the moment of the first chord and the first sound. According to Kandinsky, the "inner sound" of a work of art must produce a corresponding resonance in the soul of the viewer. "In general, colour is a means of exerting a direct influence upon the soul. Colour is the keyboard. The eye is the hammer. The soul is the piano, with its many strings. The artist is the hand that purposefully sets the soul vibrating by means of this or that key."

This notion of a synthesis of the arts combining and concentrating all spiritual forces was widespread amongst the intellectual élite of the day. It went hand in hand with the idea that art alone could vanquish materialistic thinking. The role of conqueror of the material and non-spiritual fell to the "Blue Rider", a key figure in Kandinsky's iconography. The rider motif accompanies his work from its earliest beginnings right up to its dissolution into abstract forms. The rider thereby appears in many different guises: as a romantic fairytale figure, as a medieval knight embodying the virtues, as a secret messenger, as a trumpet-blowing herald, and as Saint George, saving humankind from evil. The rider is always a symbol of search and encounter, battle and embarkation upon new challenges. The motif appears in numerous woodcuts, drawings and paintings behind glass, and in 1912 inspired the title and cover design for the *Blaue Reiter Almanac (Blue Rider Almanac)*, one of the most important compilations of programmatic writings by artists to appear this century.

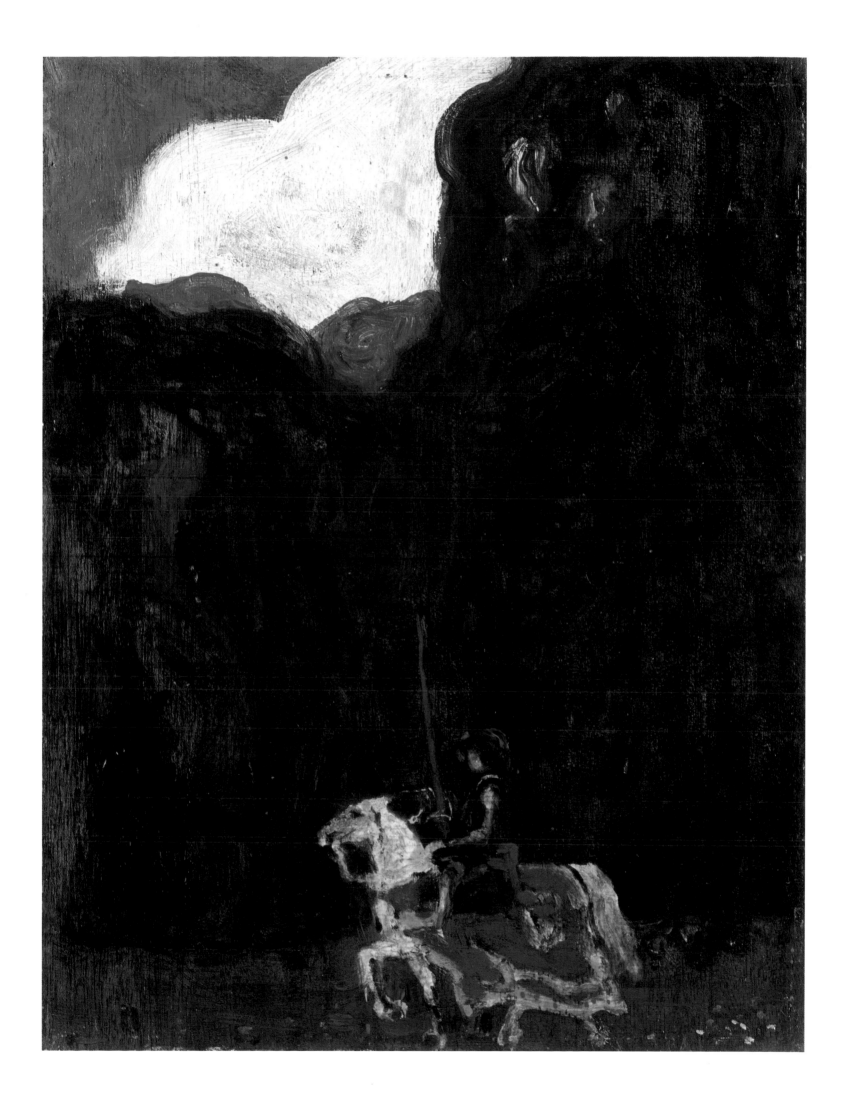

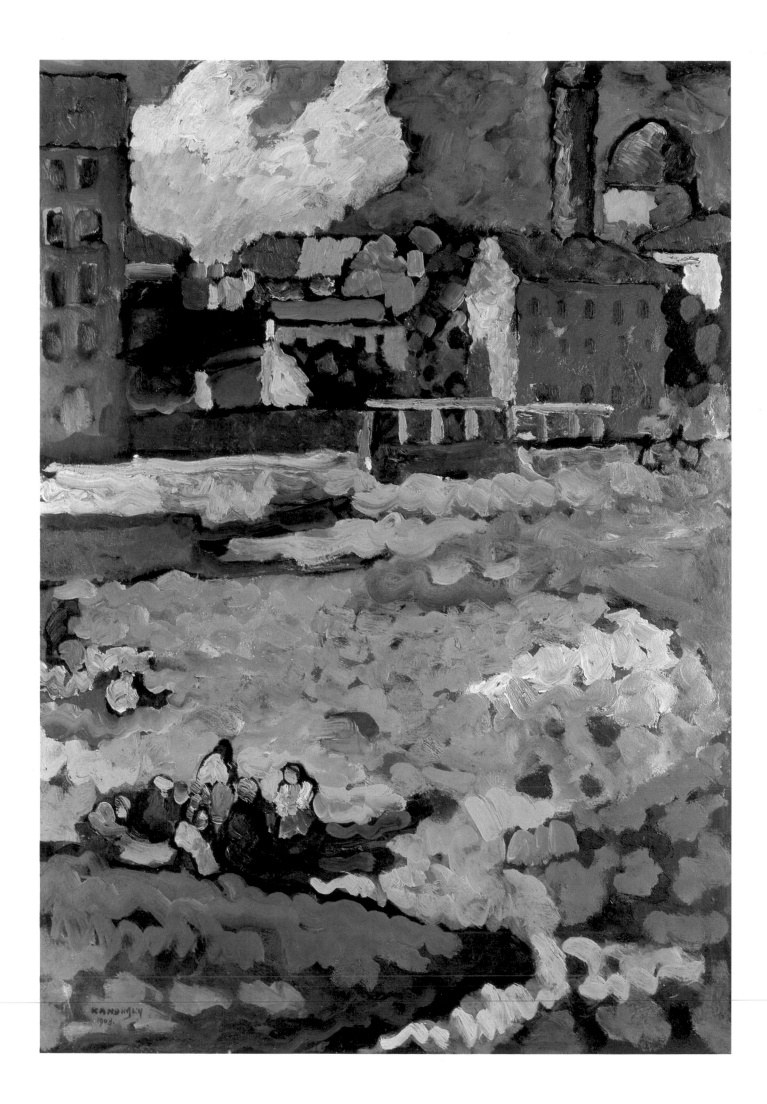

Embarking upon the journey to abstraction

After five years of extensive travelling throughout Europe, Kandinsky finally settled back in Munich in 1908. Behind him lay a period of artistic difficulties, personal problems, and even bouts of depression. His marriage to Anya Chimikian oppressed him, and his search for new pictorial means was proving painful and laborious. All these factors exacerbated his turbulent mental state, and during his last trip to Paris he almost had a nervous breakdown. Upon his return to Munich, he went first to a sanatorium to recuperate. In October 1908 Kandinsky and Gabriele Münter moved into a spacious apartment at 36 Ainmillerstraße, almost next door to Paul Klee, who was living at number 32. The two men would not properly become friends, however, until they reached the Bauhaus in the 1920s. For the next few years Kandinsky lived in Munich for all but the summer months; these he spent painting in the foothills of the Bavarian Alps, in the market town of Murnau where in 1909 Gabriele Münter bought a house.

For Kandinsky, Munich and Murnau marked the beginning of a phase of undisturbed creative activity. Apart from regular visits to his relatives in Odessa and Moscow, he was to make few other trips abroad until 1914. Instead he embarked upon an intensive exchange of ideas with artist colleagues, and in particular with his fellow Russians Alexei von Jawlensky and Marianne von Werefkin, who frequently came to paint in Murnau. Jawlensky, two years Kandinsky's senior, had also arrived in Munich from Russia in 1896 and had studied with Anton Ažbè, but had not made contact with Kandinsky until later. Jawlensky was undoubtedly the most "modern" of the Murnau group at that time. He had worked in Brittany and Provence in 1905 and knew Matisse personally. Kandinsky welcomed the stimulation offered by Jawlensky's views on art, although without adopting the latter's Synthetist style of painting, influenced by Paul Gauguin and the Pont-Aven School and characterized by powerful planes of colour heavily outlined in black.

Life in Murnau and Munich represented a new start for Kandinsky, both in artistic and in personal terms. He felt at home in the Murnau farmhouse and rediscovered the inner peace that had been missing for so long. He became an enthusiastic gardener and went for long walks in the nearby mountains. He designed elements of the décor and furnishings for the house in Murnau, including furniture decorated with folkloric ornaments and a frieze of stylized flowers and riders for the banisters, which

Gabriele Münter:
Kandinsky in a suburb of Munich
Photograph
Paris, Musée National d'Art Moderne,
Centre Georges Pompidou

PAGE 22:
Munich – Schwabing with St. Ursula's Church,
1908
München – Schwabing mit Ursulakirche
Oil on card, 68.8 x 49 cm
Munich, Städtische Galerie im Lenbachhaus

St. Ursula's church lay only two blocks from the Ainmillerstrasse, and this picture may therefore capture a view from Kandinsky's apartment. The loose brushwork and powerful palette point to French influences. Kandinsky uses the large patch of empty ground in the centre of the composition as the starting-point for a free and subjective exploration of form and colour.

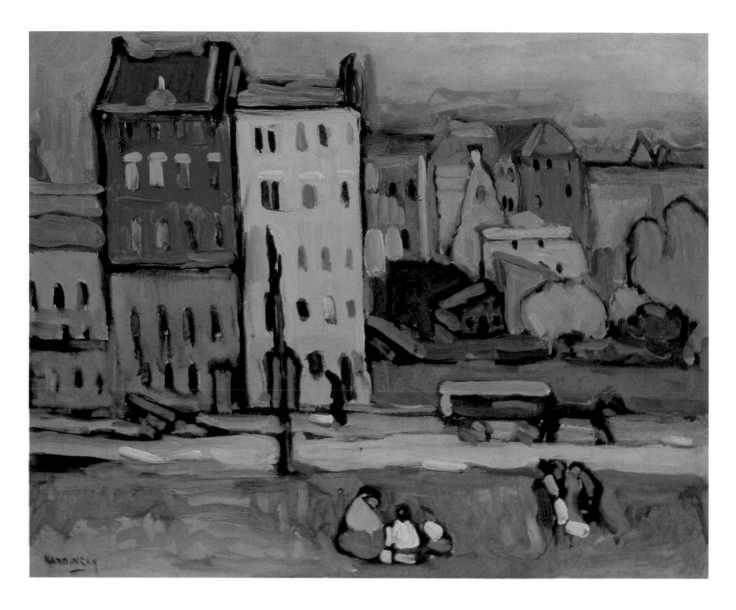

Houses in Munich, 1908
Häuser in München
Oil on card, 33 x 41 cm
Wuppertal, Von der Heydt-Museum

This is probably a view of the Hohenzollern-
straße as seen from Kandinsky's window.
Perspective and object have not yet started to
dissolve.

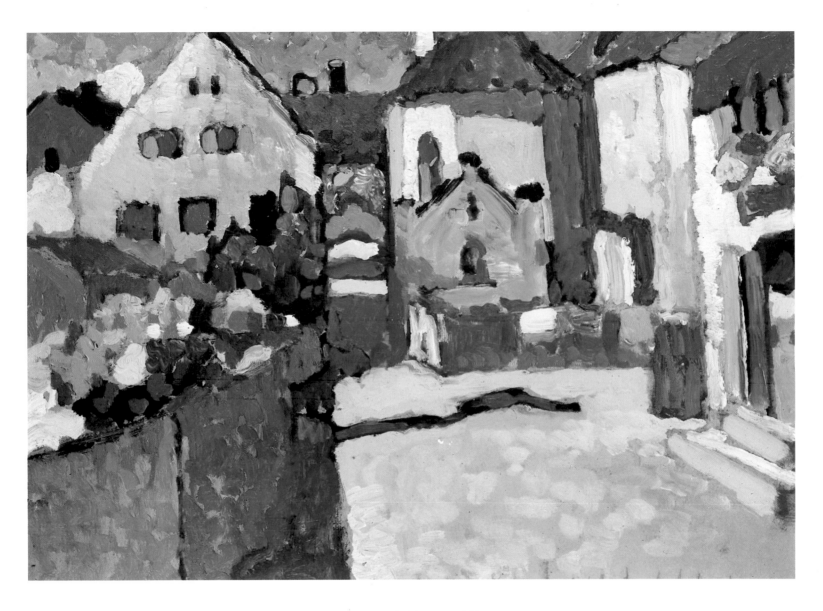

Grüngasse in Murnau, 1909
Oil on card, 33 x 44.6 cm
Munich, Städtische Galerie im Lenbachhaus

Although here, too, perspective is still intact,
Kandinsky now employs a striking palette whose
powerful, impastoed colours serve more than the
simple description of objects.

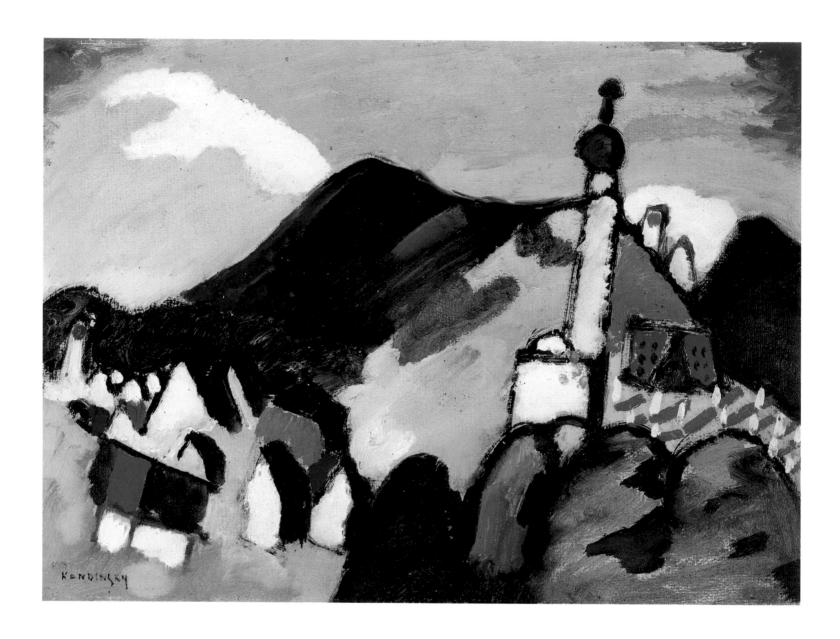

Study for **Murnau with Church II**, 1910
Murnau mit Kirche II
Oil on card, 32 x 44 cm
Private collection, on loan to the Franz-Marc-
Museum, Kochel am See

Kandinsky explored the motif of the town of
Murnau, nestled in the foothills of the Bavarian
Alps, in numerous sketches, studies and oil paint-
ings. Here, the elements of the landscape appear
as clearly-outlined planes which are stacked one
behind the other. In the portrait-format painting
opposite, however, outline and stacking are
gone; the landscape dissolves into a billowing
cloud of colour, from which the church tower
rises as the only visible remnant of the figurative
world.

PAGE 29:
Murnau with Church I, 1910
Murnau mit Kirche I
Oil on cardboard, 64.7 x 50.2 cm
Munich, Städtische Galerie im Lenbachhaus

Moscow, during which it became clear to him that "painting could de-
velop just such powers as music possesses".

The experience that Kandinsky had previously acquired in various art-
istic techniques now proved its worth. His intensive handling of the wood-
cut was particularly helpful in freeing his style. He transferred the ele-
ments of the woodcut – its planarity, linearity, saturated colouring and
"non-colours" of black and white – to oil painting. Thus *Murnau – View
with Railway and Castle* (p. 36) of 1909 reveals a strikingly flattened per-
spective. Although the picture still contains a few narrative elements,
such as the girl waving, the telegraph poles and the steam from the en-
gine, the composition is nevertheless increasingly freer and its im-
pressions of nature increasingly more subjective. The right half of the pic-
ture in particular seems to dissolve into patches of colour which can no
longer be attached to an object or fixed in space. The contrast between
the planes of saturated, impastoed colour and the black of the train lend
the painting an inner dynamism and make it sing out.

The motif of the train was not new: as a symbol of speed and progress,
it had already fascinated the Impressionists. For Kandinsky, the trains
which thundered past his Murnau garden inspired in him the desire to

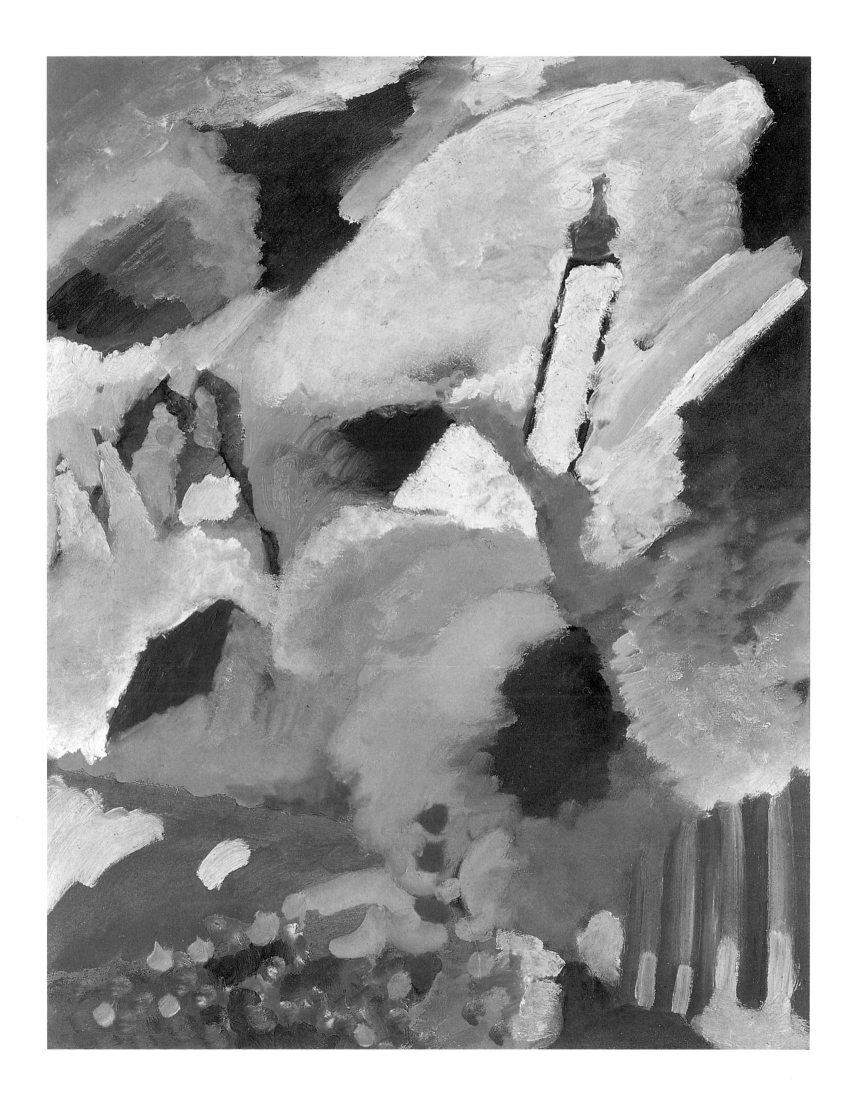

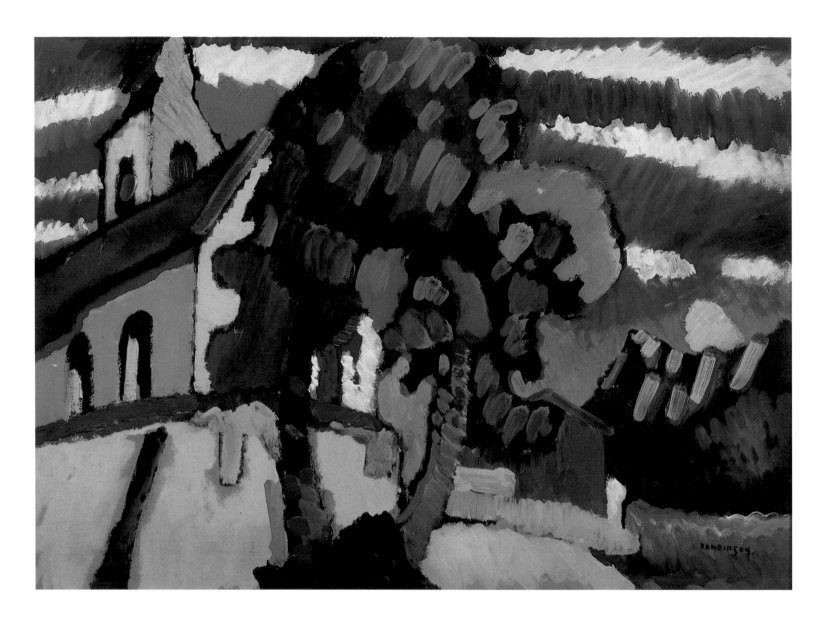

Riegsee – Village Church, 1908
Riegsee – Dorfkirche
Oil on card, 33 x 45 cm
Wuppertal, Von der Heydt-Museum

capture this multisensory experience of noise, light and shadow, dynamism and personal impressions in a vehement statement of colour.

Kandinsky was not the only artist attempting to break through the façade of the representational world in his pictures. Back in the 1880s, Vincent van Gogh had sought to bring objects of nature to life on his canvas by employing colours of maximum intensity, and thus to find truth in subjective and immediate expression. Cézanne, on the other hand, wanted to overcome the chance element in appearances and to fathom the laws of perception ("I proceed by studying Nature, in that I logically develop what we see and feel.") Cézanne's aspiration towards objective truth made him the forerunner of Cubism, whereas van Gogh prepared the ground for Expressionism. Kandinsky followed the path of neither, however. He admired both Picasso and Matisse and the daring colours of the Fauves, and must also have sympathized with the painter and theoretician Maurice Denis, one of the precursors of the Symbolist movement, who made the famous statement: "A picture – before being a horse, a nude or an anecdotal subject – is essentially a flat surface covered with colours arranged in a certain order." Kandinsky's attention was probably drawn to such theories by his compatriot Jawlensky, who was in close contact with the French art scene.

The concept of a non-objective style of painting in which colours and forms produced a comparable effect to music had long been on Kandinsky's mind. His encounter with Monet's *Haystacks* in an exhibition in Russia was later followed by a similar experience with one of his own pictures in Munich, providing him with fresh confirmation that the object represented a disturbing element in his pictures:

"Much later, after my arrival in Munich, I was enchanted on one occasion by an unexpected spectacle that confronted me in my studio. It was the hour when dusk draws in. I returned home with my painting box ... and suddenly saw an indescribably beautiful picture, pervaded by an inner glow. At first, I stopped short and then quickly approached this mysterious picture, on which I could discern only forms and colours and whose content was incomprehensible. At once, I discovered the key to the puzzle: it was a picture I had painted, standing on its side against the wall. The next day, I tried to recreate my impression of the picture from the previous evening by daylight. I only half succeeded, however; even on its side, I constantly recognized objects, and the fine bloom of dusk was missing. Now I could see clearly that objects harmed my pictures."

Kandinsky, as is clear from his theoretical writings, viewed painting as something "spiritual", something which went beyond that which can be

Kandinsky applies his powerful, suggestive colours in broad brushstrokes placed at conflicting angles. Blue-violet finds its complementary in warm yellow, red in saturated green. The landscape has become merely the starting-point for an exercise in colour. The true subject of the painting is now the power of the individual colours, their mutual interplay and their impact upon the viewer.

Murnau – Landscape with Tower, 1908
Murnau – Landschaft mit Turm
Oil on card, 75.5 x 99.5 cm
Paris, Musée National d'Art Moderne,
Centre Georges Pompidou

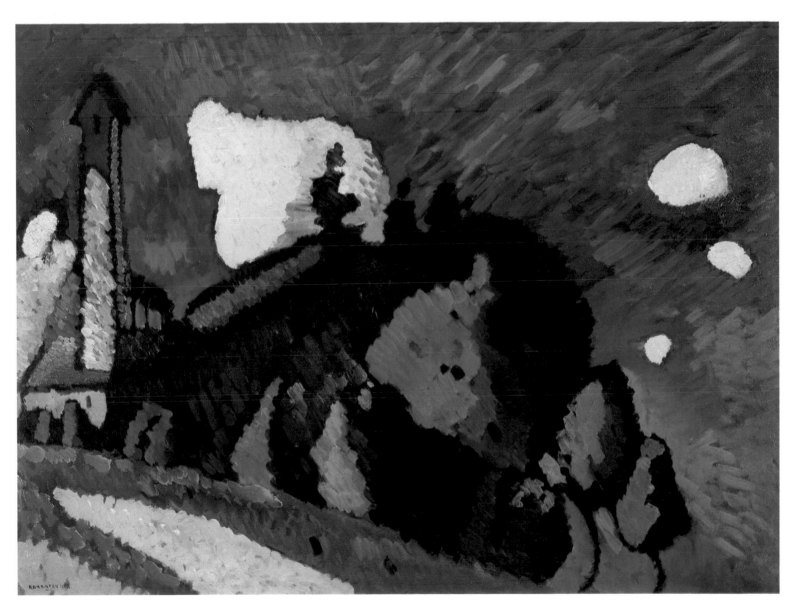

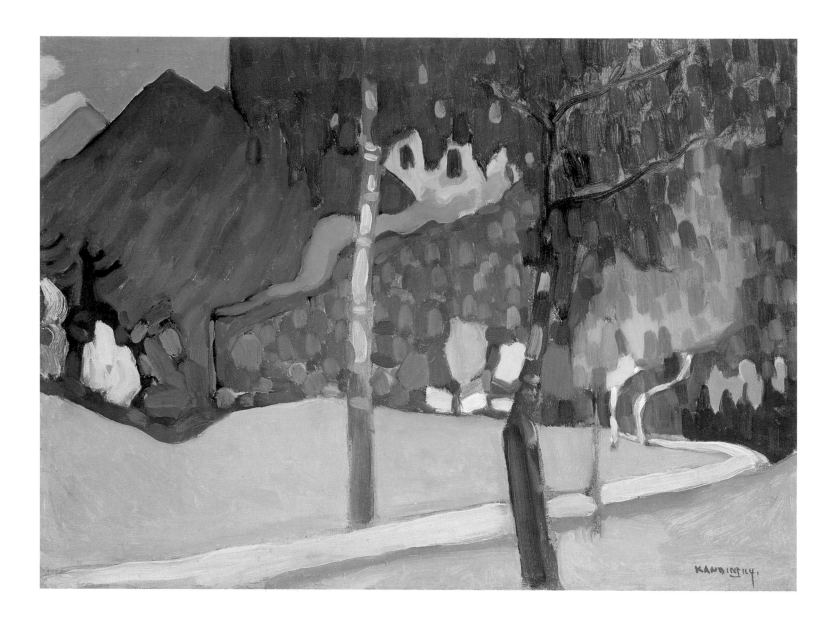

established by logic and perceived with the senses. He attempted to probe "what holds the world together at its innermost core" and sought to uncover the relationships between the individual branches of art. Freeing painting from the world of recognizable objects offered him a means of drawing closer to the secret of "the spiritual in art".

Even though Kandinsky's goal seemed to lie directly before his eyes, with the road to abstraction clearly signposted, the works which he produced between 1908 and 1910 form an unhomogeneous group and draw upon a number of different sources. Alongside French influences, reflected in Kandinsky's use of a freer, flatter pictorial structure and luminous colours, Bavarian glass painting provided a new source of inspiration for both Kandinsky and Gabriele Münter. The traditional art of painting behind glass was widespread in the Lake Staffel region, and it was probably there that Gabriele Münter discovered it. It reminded Kandinsky of his first encounter with folk art in Vologda province. Writing of the ornaments he saw decorating every object, he wrote: "They were never petty and so strongly painted that the object within them became dissolved." Votive Bavarian folk art struck the Murnau painters as authentic and still unaffected by fashionable trends or commercial considerations.

Kandinsky adopted the two-dimensionality and, in particular, the linear elements of glass painting – the fine, frequently black outlines of its forms and figures – into his own art. Indeed, line as a pictorial element would play a major role in his later works, and in 1925 he made a special study of the line and its function in the picture in *Point and Line to Plane,* one of the Bauhaus book series.

In 1909, alongside studies from nature, Kandinsky began to produce pictures in which, for the first time, motifs and objects appear mysterious and cryptic. This tendency towards concealment, towards hiding his true self, is something which emerges in his letters: "I hate it when people see what I'm really feeling," he had written to Gabriele Münter as far back as 1904. A year later his sentiments were equally strong: "Sometimes I'd like to be utterly alone in the world, estranged from the whole world, perhaps enemies with it…. Out of society with me! Absolute solitude!… No one understands me… I feel, think, dream, always want to be different from the others."

His graphic works, the woodcuts which he published under the title *Poems without Words* and *Xylographs*, were similarly full of fantastical flourishes and encoded feelings, imbued with memories of Russia and difficult to interpret. *Picture with Archer* (p. 45) is one such heavily encrypted work featuring a number of motifs from earlier compositions – a rider, human figures, a city skyline and a mountain. The symbolism of the mounted archer, turning to aim at something behind him, is unmistakable: freedom from encrusted tradition and the ballast of the past. The dappled roofs and domes of the buildings clustered against a black ground just left of centre recall the romantic tempera paintings of Russian scenes dating from Kandinsky's early Munich period. However, these identifiable objects are forced into the background by the suggestive power of the surrounding colours and forms. The expressiveness and in-

Winter I, 1909
Oil on card, 75.5 x 97.5 cm
St. Petersburg, Hermitage

Pink, light violet, deep blue and green make up the unnatural palette of this wintery Murnau scene. Although the composition remains conventional, the colours infuse the landscape with a mysterious, dreamlike atmosphere.

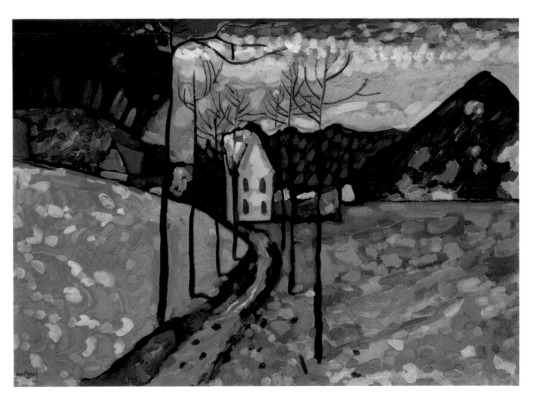

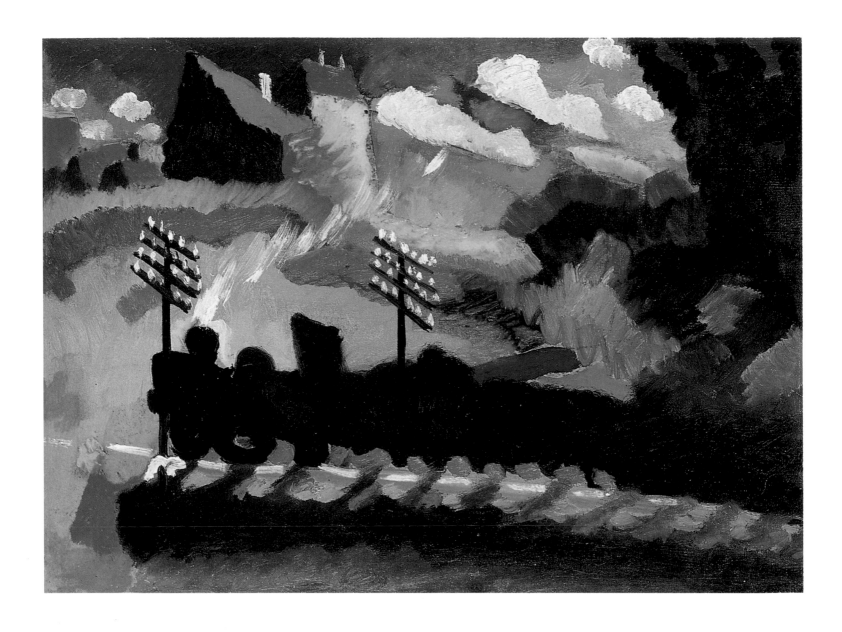

Murnau – View with Railway and Castle, 1909
Murnau – Ansicht mit Eisenbahn und Schloß
Oil on card, 36 x 49 cm
Munich, Städtische Galerie im Lenbachhaus

Kandinsky, perhaps more than other artists, gave written accounts of his artistic development throughout his life. In 1914, for example, he was invited to speak at the opening of an exhibition of his work in Cologne; he declined to appear in person, but sent instead the typescript of a lecture to be delivered on his behalf:

"My process of development," Kandinsky wrote, "consists of three periods:

1. The period of dilletantism, my childhood and youth, with its uncertain, for the most part painful emotions and, to me, incomprehensible longing." This period in Kandinsky's life was dominated by two simultaneous but fundamentally different impulses, namely a love of nature, and the indefinite stirrings of the urge to create. "This love of nature consisted principally of pure joy in and enthusiasm for the element of colour. I was often so strongly possessed by a strongly sounding, perfumed patch of blue in the shadow of a bush that I would paint a whole landscape merely in order to fix this patch… At the same time I felt within myself incomprehensible stirrings, the urge to paint a *picture*. And I felt dimly that a picture can be something other than a beautiful landscape, an interesting and picturesque scene, or the portrayal of a person. Because I loved

colours more than anything else, I thought even then, however confus-
edly, of colour composition, and sought that objective element which
could justify the [choice of] colours.

2. The period after leaving school.

It soon appeared to me that past ages, having no longer any real exist-
ence, could provide me with freer pretexts for that use of colour which I
felt within myself. Thus, I chose first medieval Germany, with which I
felt a spiritual affinity... I also created many things from within my-
selfy... freely from memory and according to my mental picture. I was far
less free in my treatment of the 'laws of drawing'... I saw with displeas-
ure in other people's pictures elongations that contradicted the structure
of the body, or anatomical distortions, and knew well that this would not
and could not be for me the solution to the question of representation.
Thus, objects began gradually to dissolve more and more in my pictures.
This can be seen in nearly all the pictures of 1910.

3. The period of conscious application of the materials of painting, the
recognition of the superfluousness, *for me*, of real forms, and my pain-
fully slow development of the capability to conjure from within myself
not only content, but also its appropriate form – thus the period of transi-
tion to pure painting, which is also called absolute painting, and the at-
tainment of the abstract form necessary for me."

Here Kandinsky is referring to the period around 1912. A little further
on in the same paper, he explains the significance of the object in his pic-
tures of around 1910 in greater depth:

"As yet, objects did not want to, and were not to, disappear altogether
from my pictures...[since] objects, in themselves, have a particular spir-
itual sound, which can and does serve as the material for all realms of art.

Landscape near Murnau with Locomotive, 1909
Landschaft bei Murnau mit Lokomotive
Oil on card, 50.4 x 65 cm
New York, The Solomon R. Guggenheim
Museum

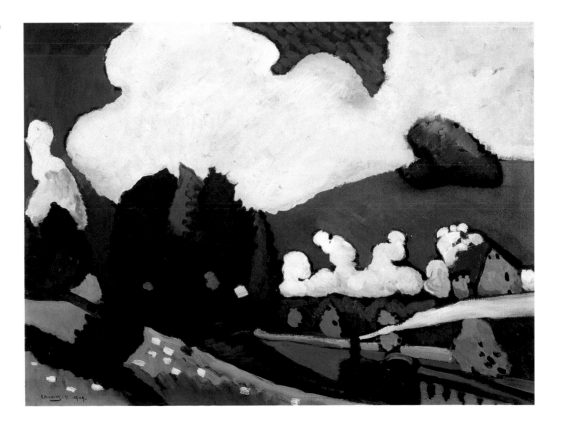

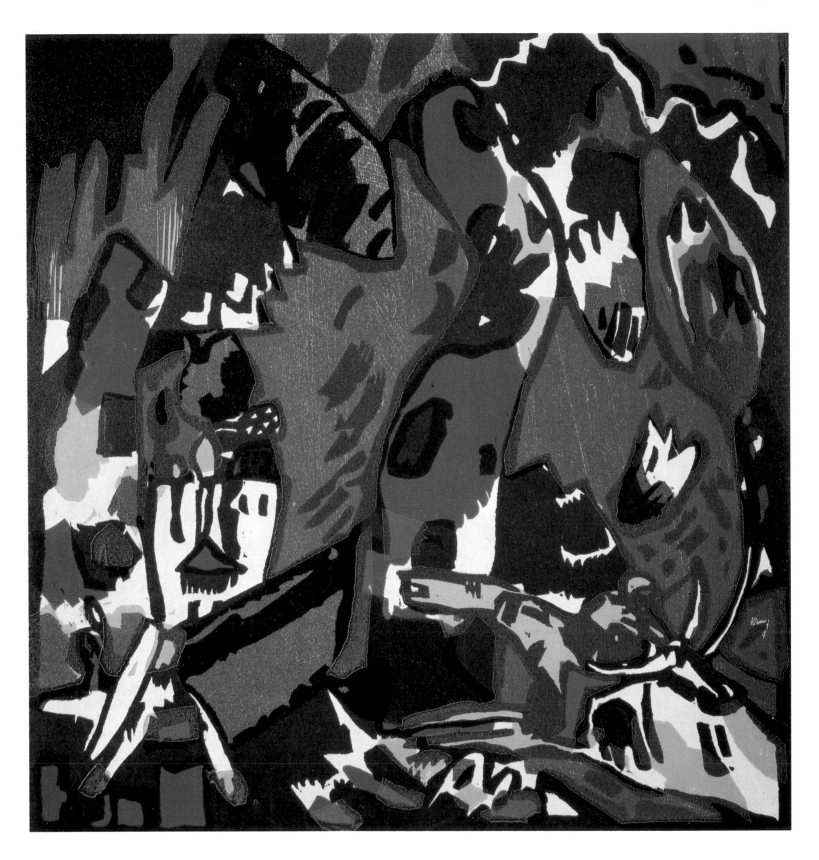

Archer, 1909
Bogenschütze
Colour woodcut on paper, 31.4 x 24.2 cm
Munich, Städtische Galerie im Lenbachhaus

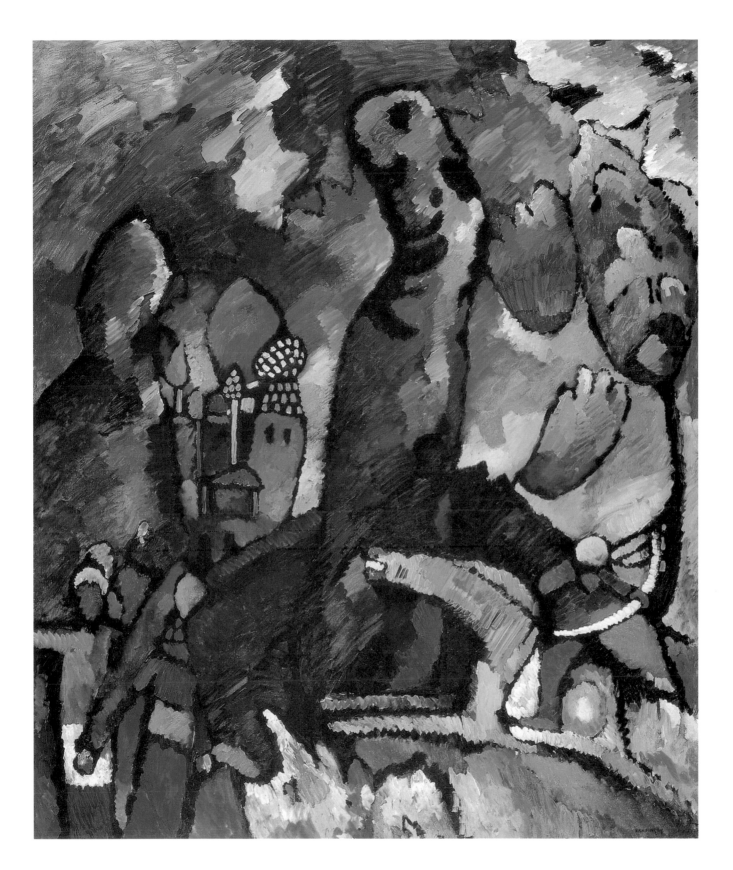

Picture with Archer, 1909
Bild mit Bogenschütze
Oil on canvas, 175.2 x 144.7 cm
New York, The Museum of Modern Art,
Fractional gift of Mrs. Bertram Smith

Alongside colour and form, line also plays an important role in Kandinsky's non-objective compositions. It is employed as a pictorial element in its own right in the top right-hand corner of *Composition II*, while in the rest of the picture, as in numerous earlier works, it serves primarily to outline planes. In *Improvisation 10* (p. 61), which was also on view at the 1910 exhibition, line assumes the same compositional status as the colour zones.

The fourth and last of the oil paintings which Kandinsky showed at the second Neue Künstlervereinigung exhibition was *Boat Trip* (p. 63), also dating from 1910. Here Kandinsky explores the use of what he called the "graphic colours" of black and white. The composition suggests a lake set within a mountainous landscape. The dark colour of the water, the light catching the building and the rowing boats gleaming white could be evocative of sunset over the lake.

Despite such narrative elements, however, Kandinsky is not in fact concerned with depicting a real situation. The boats are primarily white forms; the diagonal direction of their movement is emphasized by their oars. The lake is a black plane whose edge cuts a sharp diagonal in the centre of the picture. Two powerful horizontal lines, one yellow and one red, add further structure and correspond to the red-and-yellow stripe across the top of the picture. Kandinsky has not yet succeeded in achieving "purely abstract form without bridging the gap by means of objects"; he is still in a phase of search and experimentation. More and more, however, objects are becoming the mere vehicles of colour, and references to reality pure elements of tension.

During this period Kandinsky also eagerly absorbed influences and stimuli from non-European art. In a series of reviews written for the Russian magazine *Apollon*, he reported enthusiastically on the Eastern – and in particular Japanese and Persian – art to be seen in exhibitions in Mun-

Oriental, 1909
Orientalisches
Oil on card, 69.5 x 96.5 cm
Munich, Städtische Galerie im Lenbachhaus

In 1905 Kandinsky and Gabriele Münter spent four months in Tunisia. They lived chiefly in and around Tunis, where Kandinsky made sketches which would later form the basis for paintings. Here Kandinsky recaptures the brilliant Tunisian light and the animated bustle of an oriental market.

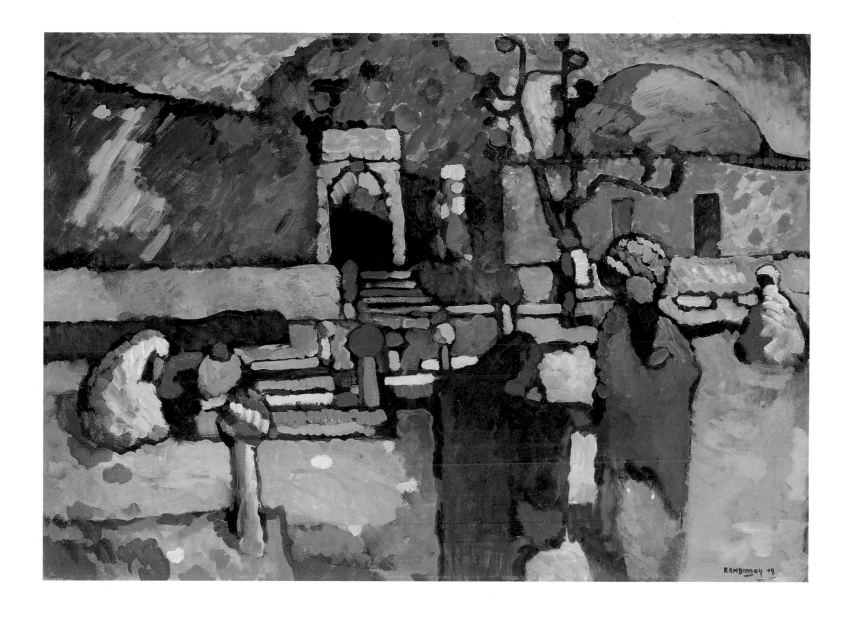

ich. In the case of Japanese art, he was especially excited by a series of woodcuts in which he sensed an "inner sound". In the Persian miniatures featured in an exhibition of Muhammadan art he recognized everything that he himself was attempting to achieve: complete detachment from reality, "primitive use of colour", and "perspective... calmly set at naught" with simple compositional means.

Amongst all the members of the Neue Künstlervereinigung, it was Kandinsky who pursued the dissolving of the object the most consistently and the furthest. This gave rise, in the spring of 1911, to disagreements with Erbslöh and Kanoldt, who were unwilling to follow Kandinsky's lead. Kanoldt, himself searching for solidity of form in his Cubist-style pictures, must have found Kandinsky's lonely path particularly unsettling, and his "disintegrating figures...profoundly repellent", as a friend of the association was later to write. Jawlensky, occupying the middle ground, attempted to play the mediator, but a split within the Neue Künstlervereinigung grew increasingly inevitable. Things came to a head when the hanging committee for the association's third exhibition rejected Kandinsky's *Composition V* (p. 81) on the grounds that it exceeded the permitted dimensions. It was Kandinsky himself who had introduced

Arabs I (Cemetery), 1909
Araber I (Friedhof)
Oil on card, 71.5 x 98 cm
Hamburg, Hamburger Kunsthalle

Sketch for *Improvisation 4*, 1909
Improvisation 4
Oil on card, 65 x 100 cm
Munich, Collection Ernst Schneider

the clause into the constitution stating that the maximum size of a picture was to be four square metres, as a way of excluding the excessive numbers of oversized works submitted by Palmié, a former member of the association. In this instance, however, the large size of *Composition V*, which measured 1.9 x 2.75 metres, simply provided the jury with an excuse; what they were really voting against was the character of the painting. Kandinsky, Marc and Münter immediately resigned from the Neue Künstlervereinigung and, under the name of "Der Blaue Reiter" (The Blue Rider), organized their own exhibition. It opened two weeks later.

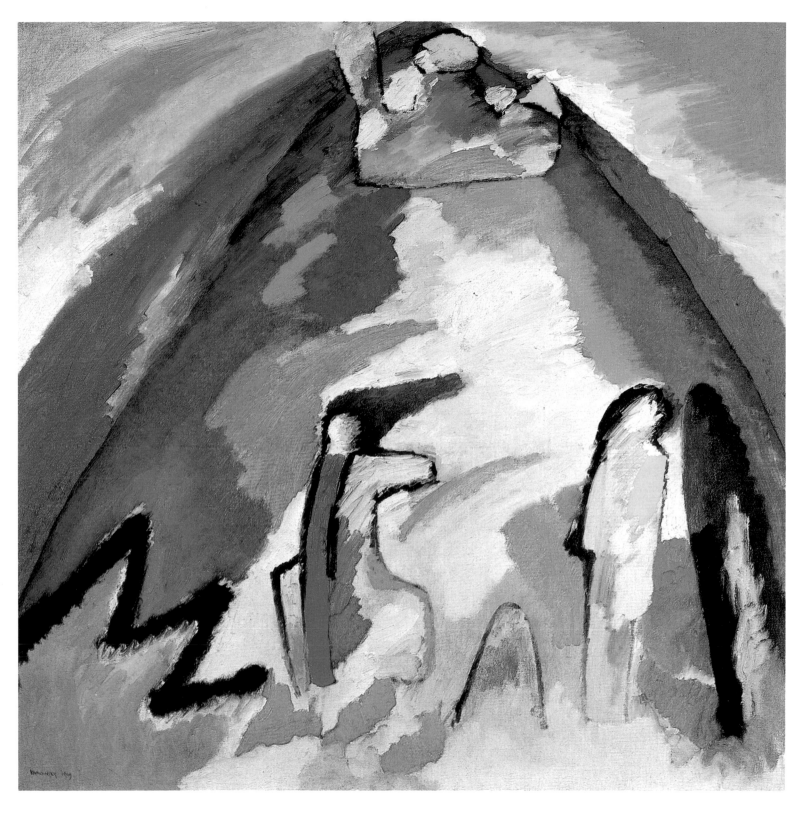

Mountain, 1908
Berg
Oil on canvas, 109 x 109 cm
Munich, Städtische Galerie im Lenbachhaus

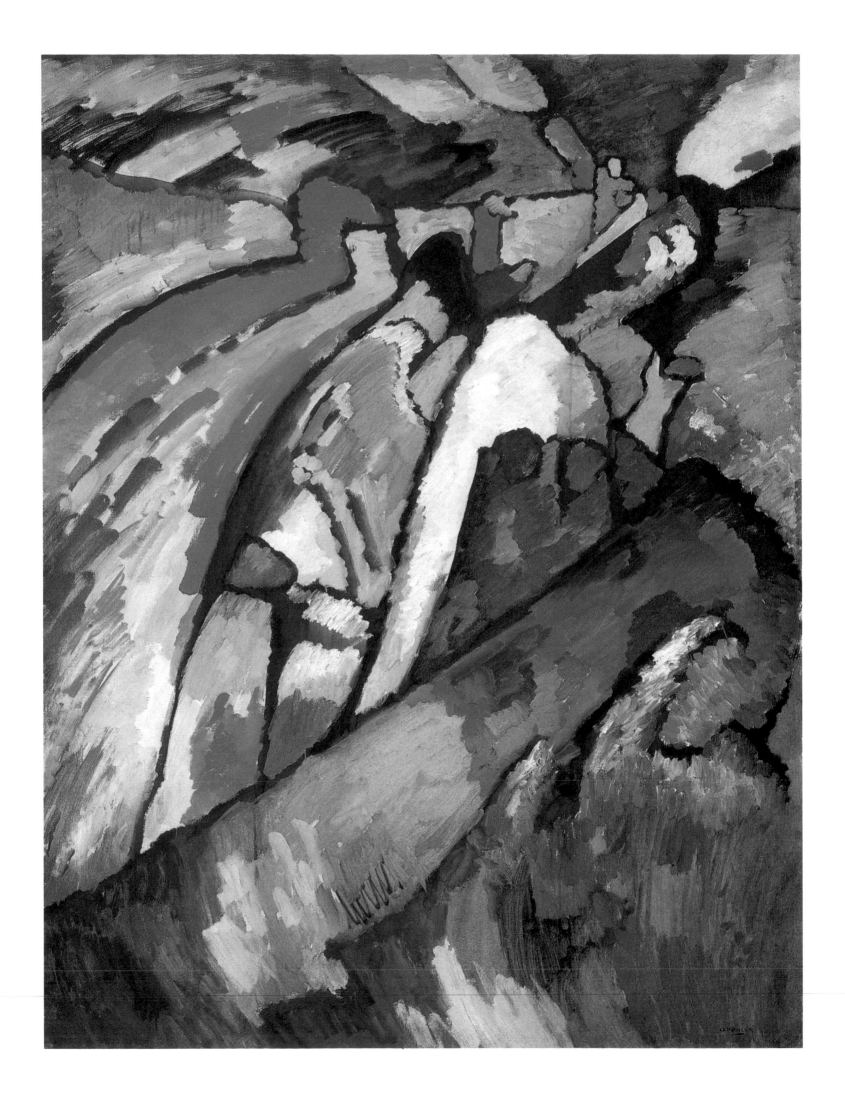

"On the Spiritual in Art"

"However interesting and informed your essay on the spiritual in art, I regret that I must decline to publish the same. – The readership of this type of theoretical treatise is unfortunately insufficiently large to guarantee the commercial success of the work, and I fear that reviewers would not be altogether favourably inclined towards the book in its present form, since the style, which suffers from numerous un-German turns of phrase, still betrays too much of a foreign hand."

Thus the response of the Munich publisher Georg Müller, to whom Kandinsky submitted a typed copy of his essay *On the Spiritual in Art* in autumn 1909. Piper Verlag also initially turned down the manuscript for stylistic reasons, but in September 1911 – probably thanks to the intervention of Franz Marc – agreed to print a first edition of 1000 copies. The author, it was stipulated in the contract, would bear half the printing costs of 1000 Marks.

By autumn 1912 the book was already into its third impression, a reflection of the enthusiasm with which it was received by the minds of the day, and in particular by young artists seeking new avenues in art.

Kandinsky's book is not easy to read: his language is full of analogy and – as the publishers had already complained – his German is flawed. German was not, after all, his mother tongue, and in places his use of the language gave rise to misunderstandings. *On the Spiritual in Art* nevertheless ranks alongside the *Blaue Reiter Almanac* as one of the documents most influential upon twentieth-century art. Kandinsky himself called it his most important theoretical work. The content of the essay was much discussed amongst his contemporaries, and it is interesting to note that, at around this same time, artists in other parts of Europe – such as Kasimir Malevich in Moscow and Piet Mondrian and František Kupka in Paris – were severing their ties with external nature in a process similar to that proposed by Kandinsky in his book and realized in his art.

Kandinsky considered it essential that a painting should grow out of what he termed an "internal necessity". This was a key concept in his theoretical writings and one which he regularly professed to be the guiding principle of all his artistic activities. A work of art, he believed, should no long depend upon an external model such as nature. Instead, the decisive factor in the genesis of a picture should be the inner voice of the artist. Thus the uncontrollable subjectivity of outer appearances would be countered by a conception based on inner impressions.

On the Spiritual in Art (Über das Geistige in der Kunst)
Cover design for the 1. edition, 1911
Paris, Musée National d'Art Moderne,
Centre Georges Pompidou

"In 1910 I had the finished text lying in my drawer, since not a single publisher had the courage to wager the (as it turned out, quite low) cost of publication. Even the warm sympathy evinced by the great Hugo von Tschudi went for nothing." (Kandinsky to Paul Westheim concerning *On the Spiritual in Art*, 1930)

"Years had to elapse before I arrived, by intuition and reflection, at the simple solution that the aims (and hence the resources too) of nature and art were fundamentally, organically, and by the very nature of the world different – and equally great, which also means equally powerful." (Kandinsky in *Reminiscences*, 1913)

PAGE 54:
Improvisation 7, 1910
Oil on canvas, 131 x 97 cm
Moscow, State Tretyakov Gallery

especially if it portrays states of minds and moods, can protect the soul from such coarsening and maintain it at a certain pitch, "as do tuning-pegs the strings of an instrument".

An art which contains no future potentialities, and which is therefore only a child of the present, is a "castrated art" in Kandinsky's opinion and will be of short duration. True art has "an awakening prophetic power". It is part of the spiritual life, which is the progress towards knowledge. The artist possesses the secret, inborn power of "vision", with which he drags "the heavy cartload of struggling humanity, getting stuck amidst the stones, ever onward and upward".

In the second chapter, entitled "Movement", Kandinsky suggests that the spiritual life can be symbolized by a triangle, divided into unequal parts, whose most acute segment is at the top. This triangle is moving slowly upwards: where the highest point is today, the next division will be tomorrow. "At the apex of the topmost division there stands sometimes only a single man. His joyful vision is like an inner, immeasurable sorrow. Those who are closest to him do not understand him and in their indignation, call him deranged: a phoney or a candidate for the madhouse. Thus, Beethoven in his own lifetime stood alone and discredited upon the peak."

Artists are to be found in every division of the triangle, each the prophet of his environment. The upward movement of the triangle is not

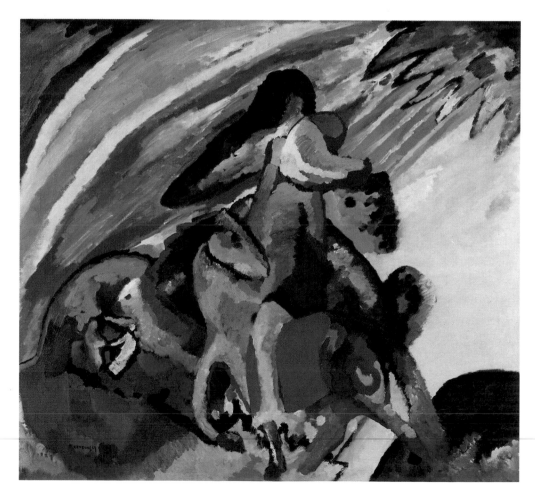

Improvisation 12 (Rider), 1910
Oil on canvas, 97 x 106.5 cm
Munich, Staatsgalerie moderner Kunst

Kandinsky's definition of an "Improvisation": "Chiefly unconscious, for the most part suddenly arising expressions of events of an inner character, hence impressions of 'internal nature'." (Kandinsky in *On the Spiritual in Art*, 1912)

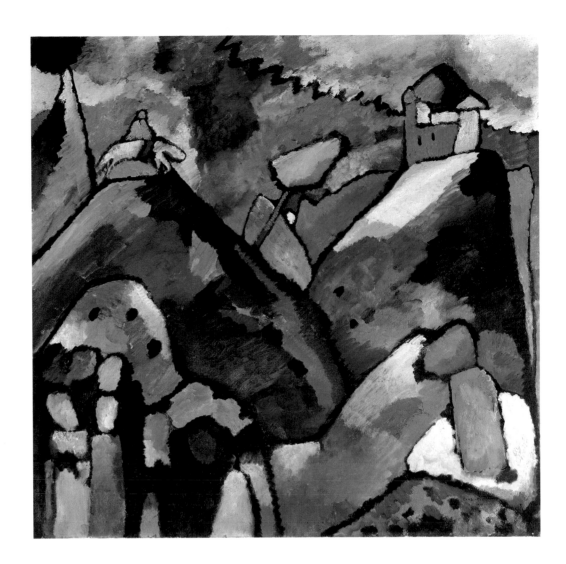

Improvisation 9, 1910
Oil on canvas, 110 x 110 cm
Stuttgart, Staatsgalerie Stuttgart

always sustained, however; at times when humankind places excessive value upon outward success and material goods, it may come to a halt or even slip downward. In such periods, art is "without a soul". "And yet, in spite of being thus continually dazzled, in spite of this chaos, this wild chase, in reality the spiritual triangle moves forward and upward, slowly but surely and with irresistible force" towards a new goal stamped by the emotion of the artist's soul.

In the third chapter, "Spiritual Turning-Point", Kandinsky polemicizes against the inhabitants of the various divisions of the spiritual triangle. He characterizes those dwelling in the large lower divisions as ignorant and lacking in initiative; they "have never managed to solve a problem for themselves." The higher one ascends the spiritual triangle, the greater the sense of scepticism towards established facts. These compartments include art historians "who write books full of praise and deep sentiments – about an art that was yesterday described as senseless." In such books, art historians merely reposition the "barriers" around art, "which this time are supposed to stay permanently and firmly in place," but which are outdated even before they are defined. These art historians fail to recognize that they are concentrating solely on the external principles of art, which are only valid for the past and not for the future. "One cannot crystallize in material form what does not yet exist in material form. The spirit that will lead us into the

Improvisation 11, 1910
Oil on canvas, 97.5 x 106.5 cm
St. Petersburg, State Russian Museum

According to Nina Kandinsky, this work hung in the dining room of their Moscow
apartment. The painting contains numerous allusions to the representational world: the
dog in the foreground, apparently uninterested in events around it and preoccupied
with itself; a boat full of people being rowed across a stormy lake; two cannons; a
rigid group of figures armed with lances; two galloping armed riders; and suggestions
of buildings. Spontaneous impressions are woven into an animated composition
which almost appears narrative in the detailed execution of certain of its components.

Boat Trip, 1910
Kahnfahrt
Oil on canvas, 98 x 105 cm
Moscow, State Tretyakov Gallery

Kandinsky uses black and white to add dramatic emphasis to this picture, which
numbers amongst his lyrical improvisations. Objects and features of the landscape are
now increasingly serving merely as symbols and vehicles of colour, while references
to reality are becoming pure elements of tension.

Improvisation 19, 1911
Oil on canvas, 120 x 141.5 cm
Munich, Städtische Galerie im Lenbachhaus

Kandinsky subtitled this painting *Blue Sound*. As
in *Impression III (Concert)* from the same year,
the composition is dominated by one colour in
particular – in this case blue, applied with a dry
brush.
"The deeper the blue becomes, the more strongly
it calls man toward the infinite, awakening in
him a desire for the pure and, finally, for the
supernatural. It is the colour of the heavens, the
same colour we picture to ourselves when we
hear the sound of the word 'heaven'."
(Kandinsky in *On the Spiritual in Art*, 1912)

"My book *On the Spiritual in Art* and the *Blaue Reiter [Almanac]*,
too," Kandinsky wrote in *Reminiscences* in 1913, "had as their principal
aim to awaken this capacity for experiencing the spiritual in material and
in abstract phenomena, which will be indispensable in the future, making
unlimited kinds of experiences possible. My desire to conjure up in
people who still did not possess it this rewarding talent was the main pur-
pose of both publications."

Nude, 1911
Akt
Watercolour, 33.1 x 33 cm
Munich, Städtische Galerie im Lenbachhaus

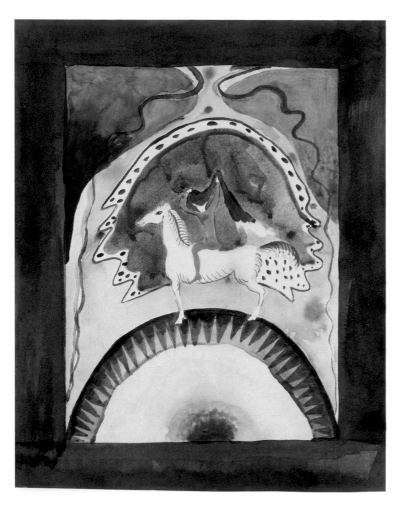

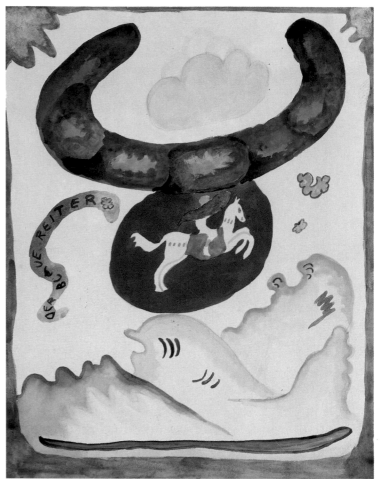

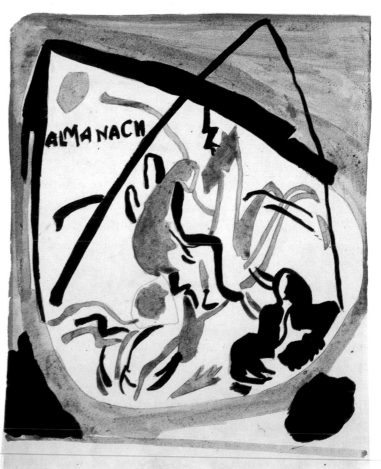

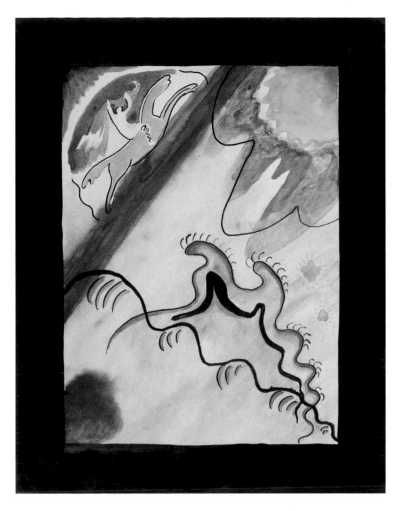

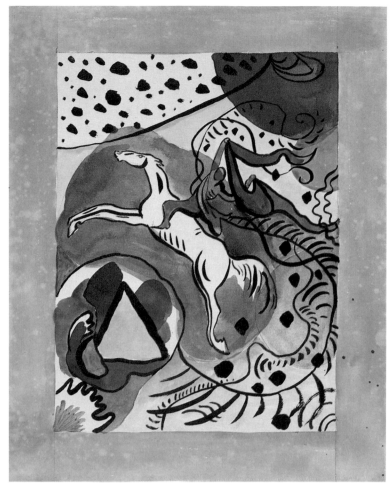

Kandinsky" (Maria Marc to Elisabeth Macke), each purchased a painting by Delaunay.

Kandinsky had long been toying with the notion of publishing some sort of almanac which, in addition to public exhibitions, would help propagate the latest ideas in art. It was particularly vital, he believed, to give artists themselves a chance to speak, since they were naturally the best qualified to talk about their aims and philosophies. He also deemed it necessary to offer an explanatory word on the contemporary trend away from naturalism, to which many critics were reacting with irritation. Such an explanation appeared all the more timely in view of the counter-offensive being launched from certain conservative – and especially anti-French – camps within Germany. Fears were being expressed that the country's museums were becoming dominated by foreign works of art, and that these posed a serious threat to home-grown art not just through their modernity but through their absorption of funds which could otherwise have gone to German artists.

It was in this climate that, at the start of 1911, the Worpswede artist Carl Vinnen published a militant paper protesting against the acquisition of French paintings by German museums. (The paper was actually inspired by the purchase of a van Gogh by the Bremer Kunsthalle; since van Gogh had spent the last years of his life in the South of France, he was generally counted as French.) Vinnen's paper prompted members of the Munich art scene to publish a counterattack, in which they argued on behalf of the French and their new art. The artists, critics, museum directors and gallery owners behind this second paper included Pauli, Osthaus,

Designs for the cover of the *Blaue Reiter Almanac*, 1911

PAGE 78, ABOVE LEFT:
Watercolour over pencil, 27.5 x 21.8 cm

PAGE 78, ABOVE RIGHT:
Watercolour over pencil, 28 x 21.7 cm

PAGE 78, BELOW LEFT:
Ink brush and watercolour over pencil, 30.6 x 23.9

PAGE 78, BELOW RIGHT:
Watercolour and ink brush over pencil and blue crayon, 27.7 x 22.3

PAGE 79, ABOVE LEFT:
Watercolour and ink over pencil, 27.7 x 21.8 cm

PAGE 79, ABOVE RIGHT:
Ink, watercolour and opaque white over pencil, 27.7 x 21.9 cm

All: Munich, Städtische Galerie im Lenbachhaus

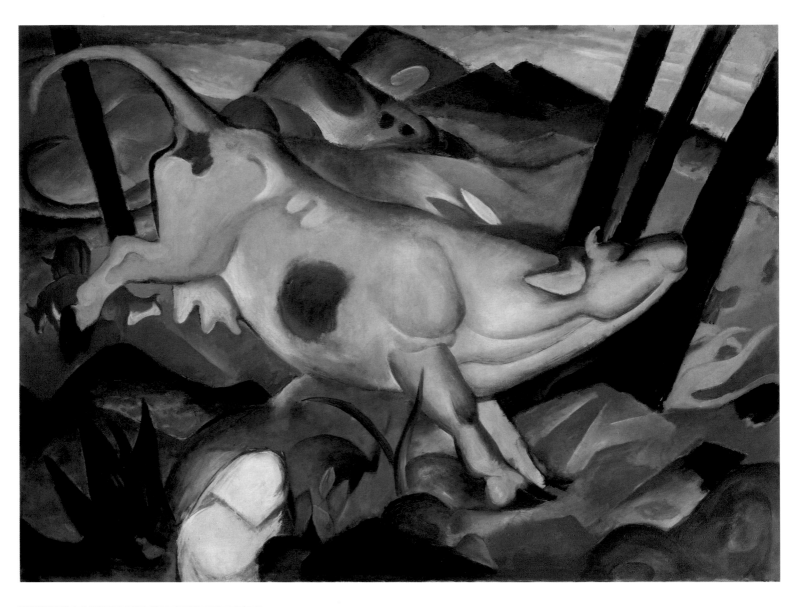

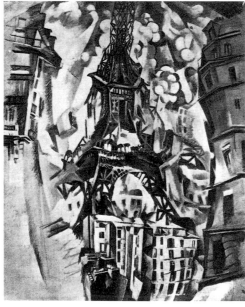

Franz Marc:
The Yellow Cow, 1911
Gelbe Kuh
Oil on canvas, 140.5 x 189.2 cm
New York, The Solomon R. Guggenheim
Museum

BELOW LEFT:
Robert Delaunay:
Eiffel Tower, 1911
Tour Eiffel
Oil on canvas, destroyed by fire in 1945, for-
merly Collection Bernhard Koehler, Berlin

BELOW RIGHT:
Franz Marc:
Deer in the Woods I, 1911
Reh im Walde I
Oil on canvas, 129.5 x 100.5 cm
Munich, Galerie Stangl, Franz Marc Bequest

"In this small exhibition, we do not seek to pro-
pagate any *one* precise and special form; rather,
we aim to show by means of the *variety* of forms
represented how the *inner wishes* of the artist are
embodied in manifold ways."
(Kandinsky in the foreword to the exhibition
catalogue)

Henri Rousseau:
The Poultry Yard, 1896–98
La Basse-Cour
Oil on canvas, 24.6 x 32.9 cm
Paris, Musée National d'Art Moderne,
Centre Georges Pompidou

Gabriele Münter:
Dark Still Life (Secret), 1911
Dunkles Stilleben (Geheimnis)
Oil on canvas, 78.5 x 100.5 cm
Munich, Städtische Galerie im Lenbachhaus

August Macke:
Indians on Horseback, 1911
Indianer auf Pferden
Oil on panel, 44 x 60 cm
Munich, Städtische Galerie im Lenbachhaus

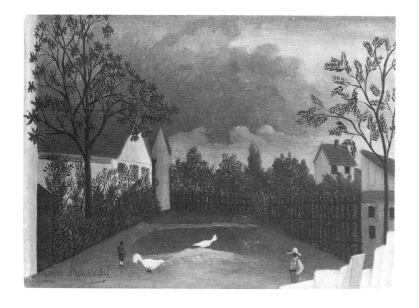

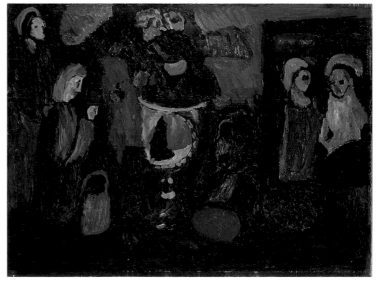

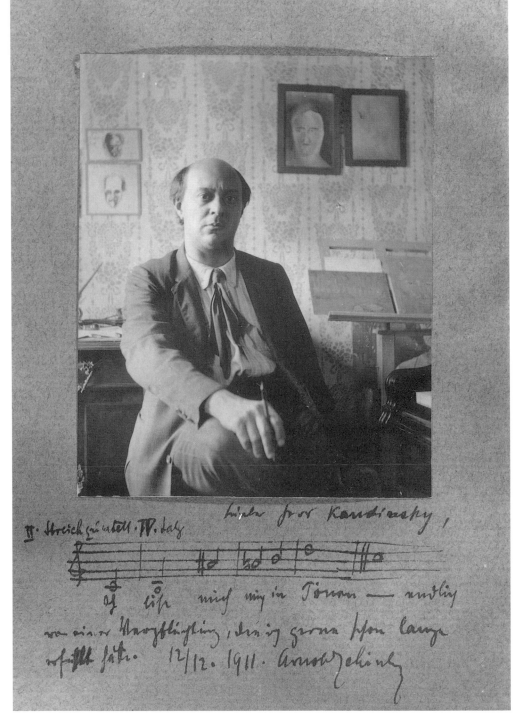

Arnold Schoenberg:
The Red Look, 1910
Der rote Blick
Oil on card, 32.3 x 24.6 cm
Munich, Städtische Galerie im Lenbachhaus
On loan from Mrs Nuria Nono

Arnold Schoenberg:
Postcard with dedication to
Wassily Kandinsky, 1911
Paris, Musée National d'Art Moderne,
Centre Georges Pompidou

Dedication to Kandinsky:
"Dear Mr. Kandinsky, I release myself (…?) in notes – at last from an obligation which I would like to have fulfilled long ago.
12.12.1911 Arnold Schoenberg"

Between 1911 and 1914 Kandinsky conducted a lively correpondence with the composer and painter Arnold Schoenberg, creator of atonal music. Kandinsky was looking in painting for what Schoenberg had already achieved in music: a new harmony based purely on laws immanent in art.

"Schoenberg's music leads us into a new realm, where musical experiences are no longer acoustic, but *purely spiritual*. Here begins the 'music of the future'."
(Kandinsky in *On the Spiritual in Art*, 1912)

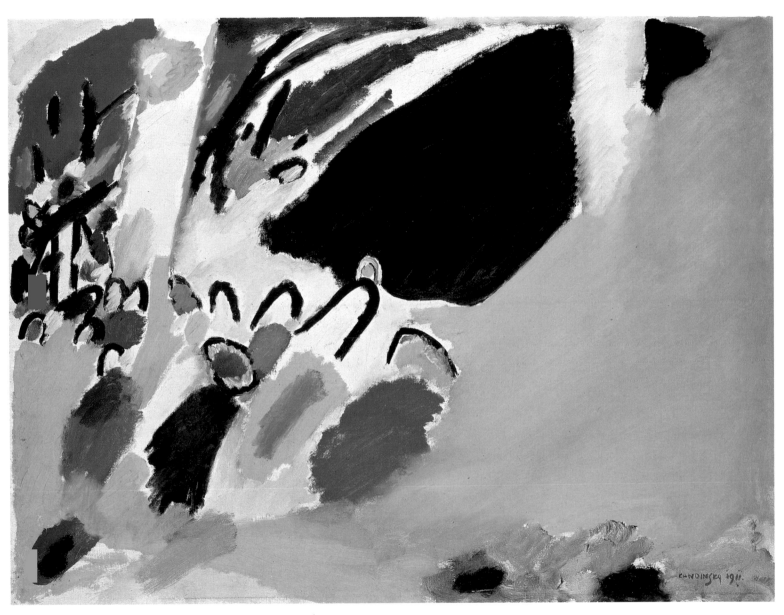

Impression III (Concert), 1911
Impression III (Konzert)
Oil on canvas, 77.5 x 100 cm
Munich, Städtische Galerie im Lenbachhaus

This painting arose shortly after Kandinsky had attended the first Munich concert of Schoenberg's music. The concert, given in January 1911, also marked the start of the correspondence between the two artists. The dominating colours are yellow and black, whereby the black form recalls the shape of a grand piano, the most important instrument in Schoenberg's concert. The painting reflects Kandinsky's capacity for intense synaesthetic experience. For him, the most powerful means of expression lay in the sound of colours, which he believed both could and should be dissonant ("The opposite of harmony is disharmony. And throughout the history of the painting the disharmony of yesterday has always become the harmony of today."). In *On the Spiritual in Art*, Kandinsky described the properties of yellow and black as follows: "Yellow...is disquieting to the spectator, pricking him, stimulating him, revealing the nature of the power expressed in this colour, which has an effect upon our sensibilities at once impudent and importunate. This property of yellow, a colour that inclines considerably toward the brighter tones, can be raised to a pitch of intensity unbearable to the eye and to the spirit. Upon such intensification, it affects us like the shrill sound of a trumpet being played louder and louder, or the sound of a high-pitched fanfare...

Black has an inner sound of...an eternal silence without future, without hope... Black is externally the most toneless colour, against which all other colours...sound stronger and more precise."

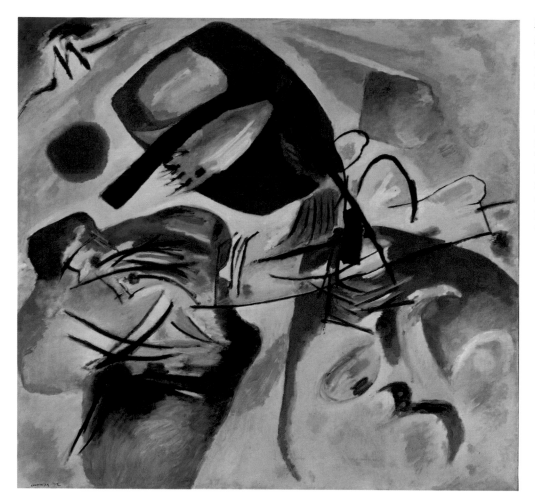

Picture with a Black Arch, 1912
Bild mit schwarzem Bogen
Oil on canvas, 188 x 196 cm
Paris, Musée National d'Art Moderne,
Centre Georges Pompidou

"Painting is like a thundering collision of different worlds that are destined in and through conflict to create that new world called the work. Technically, every work of art comes into being in the same way as the cosmos – by means of catastrophes, which ultimately create out of the cacophony of the various instruments that symphony we call the music of the spheres." (Kandinsky in *Reminiscences*, 1913)

barking upon the new, and all of them featuring the motif of the rider. In one case this takes the form of a static combination of a horse and child rider on the summit of a mountain (p. 78, above left), in which the rider holds aloft a blue cloth to greet a new age in a flat, almost symmetrical composition reminiscent of traditional glass painting. Elsewhere, on the other hand, Kandinsky places greater emphasis on movement, setting a galloping rider holding a blue cloth against a red halo (p. 78, above right). Blue and red are here employed in a powerfully resonant contrast.

In another study (p. 79, above left), the rider appears deep in the top left-hand corner, charging across the heavens. Kandinsky's use of opposing diagonals infuses the composition with a powerful dynamism and carries it further away from the representational world. This pronounced diagonal movement reappears in another version (p. 79, above right), although in this case it is modified by compositional elements such as the field of black dots above left, the daubs of black scattered across the surface and the independent undulating lines below right. This picture includes a new motif, seen in the bottom left-hand corner: a yellow triangle against a blue, irregularly-shaped background, which has been variously interpreted as a sailing boat, a geometrical form in the mystical sense, and a miniature mountain over which the rider is jumping.

In another case (p. 78, below left), the rider is depicted only schematically by a black outline within a blue oval, while the remaining forms in the picture correspond to no obviously recognizable objects. The motif of the charging rider has here been reduced to an emblem.

Kandinsky adopts a more narrative, situational approach in another version (p. 78, below right): horse and rider are stopped by the irregular dark form of a figure kneeling before them. This figure may be interpreted as the beggar who appeared before St. Martin or the dragon confronting St. George.

St. George is also the centrepiece of the design finally chosen for the cover of the *Blaue Reiter Almanac* (p. 76). Beneath the horse's rearing front hooves we see the king's daughter, destined to be sacrificed to the dragon before her legendary rescue by St. George. Of the dragon itself, only the mottled tail is visible.

The story of St. George and the dragon was a popular theme both in Russian icon painting and in Bavarian votive art. Kandinsky treated the motif of the dragon-slayer in a number of media, including oils, glass paintings, woodcuts and sketches. In *St. George I*, a glass painting of 1911 (p. 73), the saint is a fearless knight portrayed in the act of dealing the deathblow to his opponent. Kandinsky expresses the dramatic tension of the situation through his use of opposing diagonals. The chief line of movement runs top right to bottom left though the lance, ending in a patch of orangey-red – the wound in the dragon's hindquarters. This line is crossed by the second main diagonal, indicated by the fiercely-braking horse. Line and colour – the unnatural blue of the horse, the yellow dots and strident patches of red – combine to form an animated composition which captivates the viewer through its dramatic intensity and immediacy.

The rider in the final design for the *Almanac's* cover is similarly a symbol of the warrior and the saviour. He brings society, personified in the virgin, salvation from the evils of materialism, represented by the dragon.

Picture with a White Form, 1913
Bild mit weißer Form
Oil on canvas, 120.3 x 139.6 cm
New York, The Solomon R. Guggenheim
Museum

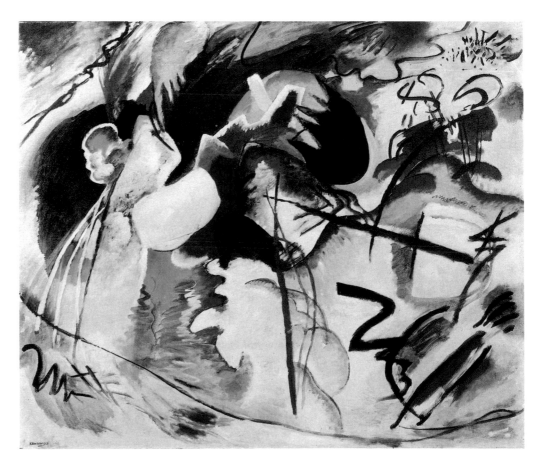

"In this picture one can see two centres:
1. on the left the delicate, rosy, somewhat blurred centre, with weak, indefinite lines in the middle;
2. on the right (somewhat higher than the left) the crude, red-blue, rather discordant area, with sharp, rather evil, strong, very precise lines. Between these two centres is a third (nearer to the left), which one only recognizes subsequently as being a centre, but is, in the end, the principal centre. Here the pink and the white seethe in such a way that they seem to lie neither upon the surface of the canvas nor upon any ideal surface. Rather, they appear as if hovering in the air, as if surrounded by steam. This apparent absence of surface, the same uncertainty as to distance can, e.g., be observed in Russian steam baths. A man standing in the steam is neither close to nor far away; he is just somewhere. This feeling of 'somewhere' about the principal centre determines the inner sound of the whole picture." (Kandinsky in *Reminiscences*, 1913)

The motif of the rider as saviour featured in other works reproduced in the *Almanac*, for example in a Bavarian mirror painting showing St. Martin cutting his cloak in half to give it to the beggar, which appeared as the frontispiece opposite the title page. It subsequently recurred in *Archer*, the colour woodcut forming the second frontispiece to the de luxe edition of the *Almanac*, whose motif is the same as that of Kandinsky's large oil, *Picture with Archer*, of 1909 (p. 45). Peg Weiss has identified the rider here as Apollo, the divine archer who wards off evil and brings salvation.

The *Almanac* embraced a broad range of topics. It comprised essays on painting, music and theatre, plus modern compositions by Arnold Schoenberg, Anton von Webern and Alban Berg. The texts were accompanied by 144 illustrations, including Bavarian and Russian folk art, medieval woodcuts, Egyptian shadow-play figures, dance masks, sculpture from Cameroon and Mexico, Chinese paintings, Japanese pen-and-ink drawings, classical art and children's drawings. In addition to works by Kandinsky, Marc and Kubin, modern art was represented by Picasso, Delaunay, Matisse and the Berlin group Die Brücke (The Bridge), as well as by the "fathers of Modernism" van Gogh, Cézanne, Gauguin and Rousseau. In keeping with the ideas of Blaue Reiter editors Kandinsky and Marc, the illustrations were chosen for their "internal life", their true "inner sound". They were then juxtaposed within the *Almanac* so that the "inner sound" of one work would bring out the "counter-resonance" of another. "If the reader of this book is temporarily able to banish his own wishes,

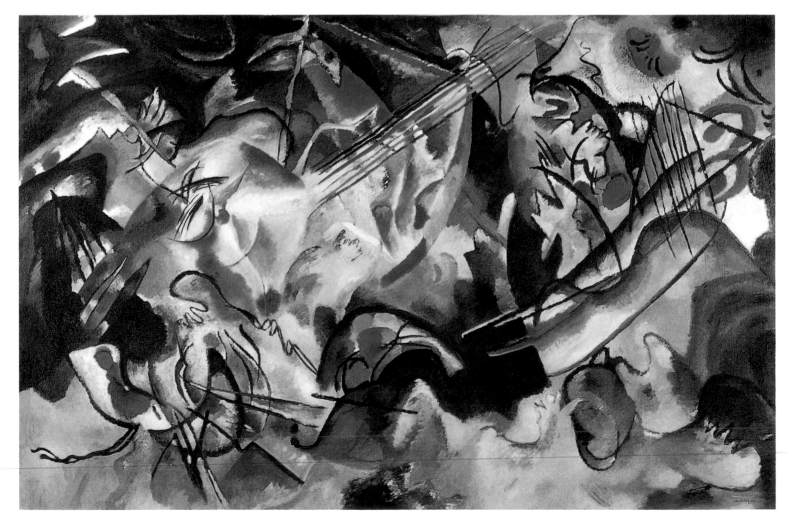

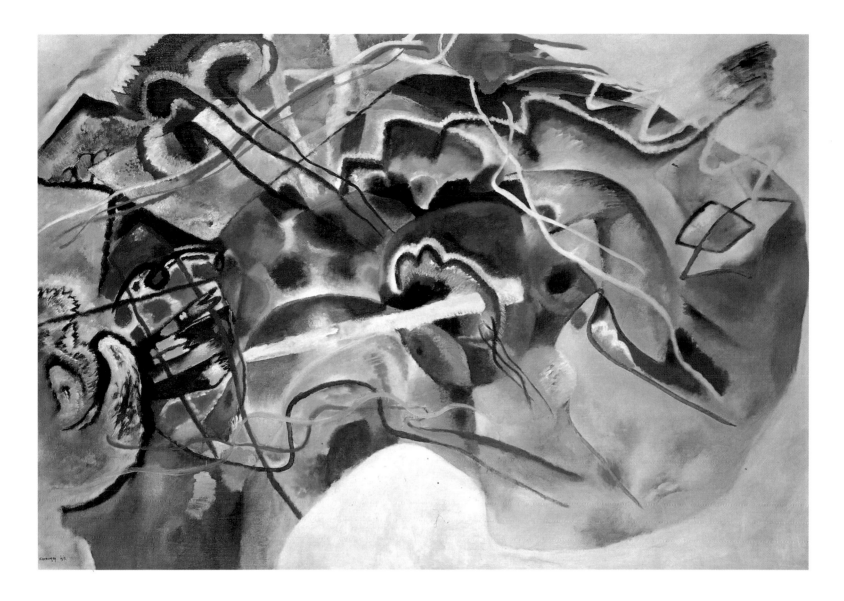

thoughts and feelings, and then leafs through the book, passing from a vo- tive picture to Delaunay, from Cézanne to a Russian folk-print, from a mask to Picasso, from a glass picture to Kubin, etc.," wrote Kandinsky in his *Almanac* essay "On the Question of Form", "then his soul will experi- ence a multitude of vibrations and enter into the realm of art... These vi- brations and the plus that derives from them will be a kind of enrichment of the soul that cannot be attained by any other means than those of art."

Almost half the texts in the *Almanac* were written by Kandinsky him- self. He was the driving force behind the project, editing and translating the contributions from Russian authors and organizing the reproductions. He was enthusiastically supported by Franz Marc, "an absolute magician and on top of that a true friend," as Kandinsky wrote to Alfred Kubin.

In 1914 the *Almanac* went into a second edition. A second volume was planned, but never published. There was, however, one more Blaue Rei- ter exhibition, held in 1912 at Hans Goltz's gallery in Munich. The ex- hibition was devoted to over 300 works on paper by German, French and Russian artists, and included a large number of watercolours by the art- ists of Die Brücke – still largely unknown in Munich – which Marc had brought back from Berlin. Paul Klee, Kandinsky's neighbour in Ainmil- lerstraße, also exhibited for the first time with the Blaue Reiter at this ex- hibition. He had met Kandinsky, Marc and Macke at the anatomy class

***With a White Border**, 1913*
Mit weißem Rand
Oil on canvas, 140.3 x 200.3 cm
New York, The Solomon R. Guggenheim
Museum

"I had no desire to introduce into this admittedly stormy picture too great an unrest. Rather, I wanted, as I noticed later, to use turmoil to ex- press repose... I treated this white edge itself in the same capricious way it had treated me: in the lower left a chasm, out of which rises a white wave that suddenly subsides, only to flow around the right-hand side of the picture in lazy coils, forming in the upper right a lake..., disap- pearing toward the upper left-hand corner, where it makes its last, definitive appearance in the pic- ture in the form of a white zigzag."
(Kandinsky in *Reminiscences*, 1913)

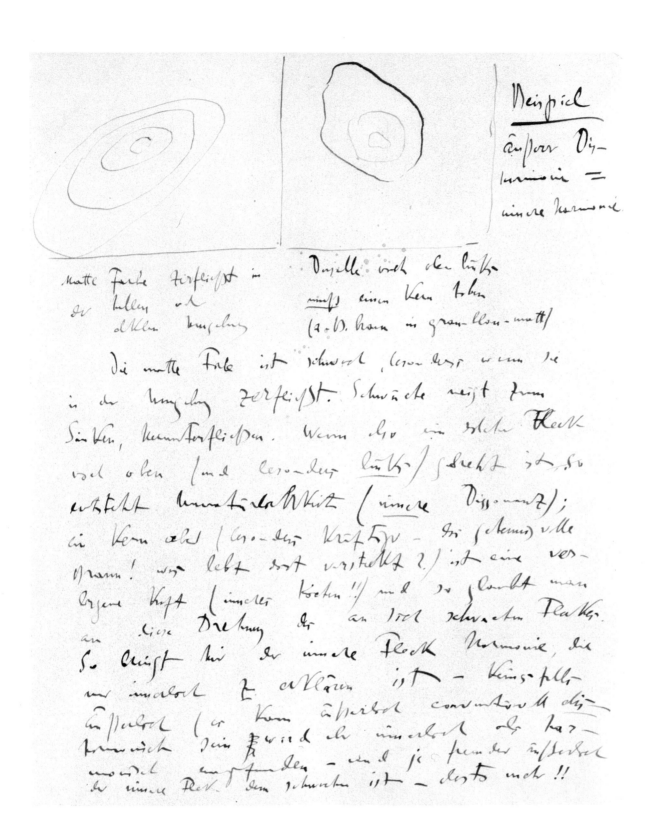

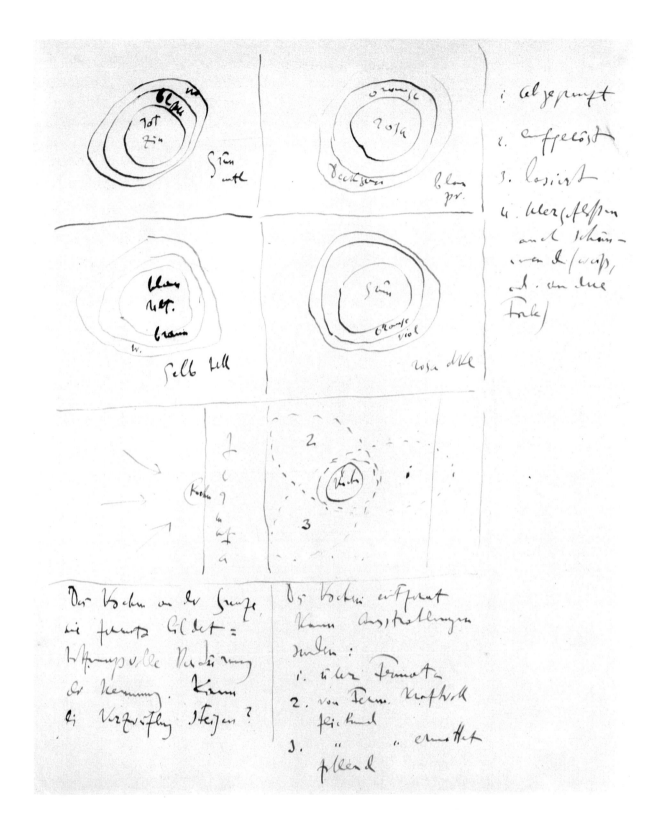

Here Kandinsky explores the relationship between colour and contour and the effects of colour on the edges of neighbouring colours. Following his exhaustive investigations into the interplay of colour and form, Kandinsky was later to conclude: "'Absolute means' do not exist in painting; its means are relative only. This is a positive and cheering fact, since it is from interrelation that the unlimited means and inexhaustible richness of painting arise."
(Kandinsky in "The Value of a Concrete Work", *XXe Siècle*, 1938)

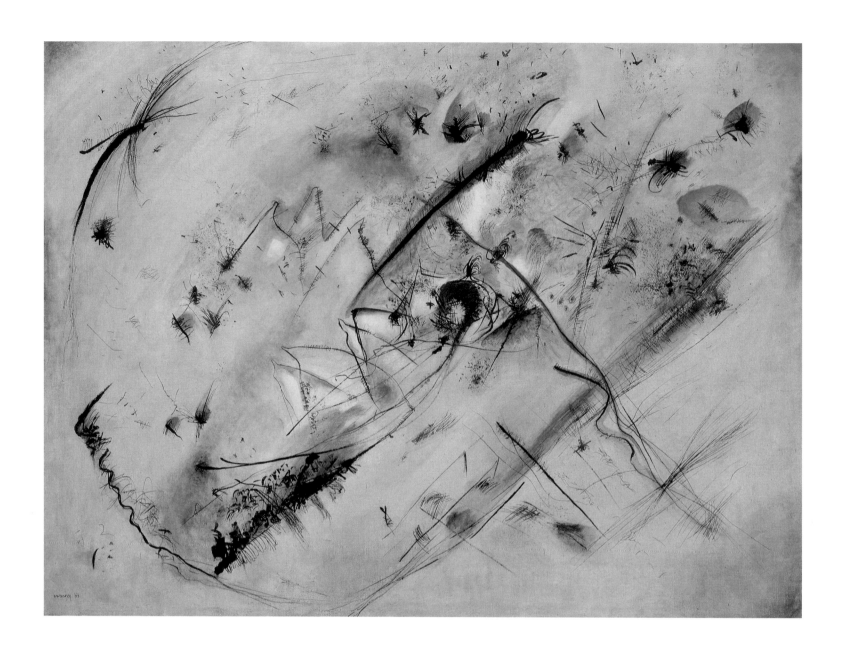

Bright Picture, 1913
Helles Bild
Oil on canvas, 77.8 x 100.2 cm
New York, The Solomon R. Guggenheim Museum, Gift of Solomon R. Guggenheim, 1937

which is tensely juxtaposed with a patch of outward-thrusting blue. Red, the third primary colour, is used more sparingly. In its warmth, however, it replies to the sharp contrast of blue and yellow. "Opposites and contradictions – this is our harmony," wrote Kandinsky in *On the Spiritual in Art*. "Composition on the basis of this harmony is the juxtaposition of colouristic and linear forms that have an independent existence as such, derived from internal necessity, which create within the common life arising from this source a whole that is called a picture."

Not all Kandinsky's works from this period are as close to abstraction as *Improvisation 26 (Rowing)*, however. Around 1911 he produced a number of pictures with religious themes in which figures and objects are stylized in the manner of folk art (*All Saints, Deluge, St. George*). In this case his inspiration came from Bavarian glass painting, with its bold colours and naïve forms of expression.

Kandinsky painted a number of versions of *All Saints* in watercolour, oil, and on glass (pp. 84/85). Underlying such All Saints pictures was the vision of an *unio sanctorum*, a chorus of saints which, together with representatives of every race, nation and language, worships the Lamb,

the symbol of Christ. Kandinsky frequently expanded this theme to include the Last Judgement and the Apocalypse. In the oil painting *All Saints I* of 1911 (p. 84), he focusses upon the onset of natural catastrophes and the Apocalypse. Only a few details can be confidently identified: a trumpeting angel (heralding the arrival of the Last Judgement), a rider, and two figures standing close together facing towards the viewer. The remaining fragments can no longer be deciphered. The picture dissolves into an animated tangle of splintered forms in light, cool colours, thrown into a spiralling vortex by the blast of the trumpet. In *All Saints II* (p. 85, below), by contrast, numerous figures are clearly outlined and the whole is closer to the glass paintings. The composition is nevertheless looser than in the first version, with the figures appearing to float in space as if in a trance.

Entirely different again was the monumental *Picture with a Black Arch* of 1912 (p. 88). It is a wholly abstract composition. The pictorial plane is dominated by three powerful colour forms which appear to be moving towards collision. The underlying theme of the painting is battle and conflict, bringing to mind Kandinsky's words from *Reminiscences*: "Painting is like a thundering collision of different worlds that are destined in and through conflict to create that new world called the work. Technically, every work of art comes into being in the same way as the cosmos – by means of catastrophes, which ultimately create out of the cacophony of the various instruments that symphony we call the music of the spheres." As if in a cosmic vortex, the forms in *Picture with a Black Arch* appear to rotate around the centre in a slow but inexorable movement. The dramatic atmosphere of coalition and opposition between the colours and forms is fuelled above all by the threateningly heavy red-violet form at the upper edge of the composition.

In its shape and position, this red-violet form resembles the enigmatic black form in *Lady in Moscow* (p. 90), which also dates from 1912. Here, two purely painterly inventions – an opaque black block and a pink, cloud-like disk – are incorporated into a relatively naturalistic Moscow street scene in a strange and disconcerting manner. The icon-like figure of the woman in the foreground, surrounded by a blue aura, harks back to glass painting, while the street vanishing towards the towers of the Kremlin, with its carriage, dog and messenger, recall Kandinsky's street scenes from Murnau and Munich. These influences combine with abstract formations, such as the black, sharply defined form appearing to insert itself between the woman and the sun, into a mysterious and dramatic composition. The woman's aura can be interpreted as a protective cloak, a zone of vital energy which issues from the sun. The black patch is steering towards this vital energy and is already starting to block the sun. According to Riedl, the black patch can be read as the "fall of materialistic darkness over the sphere of communication between eternal light and beings in search of enlightenment", a reference to theosophical ideas, which Kandinsky had studied in depth.

Shortly after *Lady in Moscow*, Kandinsky painted *Black Spot I* (p. 91). The only surviving allusions to the representational world are found in an onion-domed church perched on a mountain in the bottom left-hand corner, and a three-horse carriage driving out of the picture above left – the

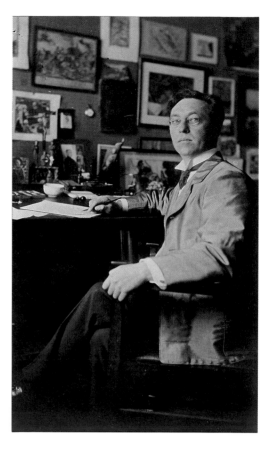

Kandinsky in Munich, 1913
Photograph
Paris, Collection Gilles Néret

Drawing No. 5, 1912
Zeichnung Nr. 5
Ink, 29.5 x 14 cm. Paris, Musée National d'Art Moderne, Centre Georges Pompidou

satisfaction", which featured numerous narrative motifs such as animals, naked figures, the ark, palm trees, lightning and rain. Kandinsky wanted to develop the subject into a *Composition*, and he made a number of preliminary designs and sketches as part of this process. In some of them he partially dissolved the corporeal forms, in others he sought to achieve his effect with purely abstract means. For a long time, however, he was unable to capture the "inner sound" of the word "Deluge" and to free himself from external, mimetic impressions. Kandinsky compares himself during this phase to "a snake not quite able to slough its skin". "Finally," however, "the day came, and a well-known, tranquil, inner tension made me fully certain. I at once made, almost without corrections, the final design, which in general pleased me very much. Now I knew that under normal circumstances I would be able to paint the picture... Nearly everything was right the first time. In two or three days the main body of the picture was complete. The great battle, the conquest of the canvas, was accomplished."

How exactly does Kandinsky succeed in freeing himself from the external impression of the word "Deluge"?

He begins by placing small, splintered and interlocking forms on the canvas; he then calms the unrest these produce with long, "solemn" lines. To mitigate the dramatic effect of the lines, he creates "a whole fugue out of flecks of different shades of pink, which plays itself out on the canvas. Thus, the greatest disturbance becomes clothed in the greatest tranquility, the whole action becomes objectified. This solemn, tranquil character is, on the other hand, interrupted by the various patches of blue, which produce an internally warm effect. The warm effect produced by this (in itself) cold colour thus heightens once more the dramatic element in a noble and objective manner. The very deep brown forms (particularly in the upper left) introduce a blunted, extremely abstract-sounding tone, which brings to mind an element of hopelessness. Green and yellow animate this state of mind, giving it the missing activity... So it is that all these elements, even those that contradict one another, inwardly attain total equilibrium, in such a way that no single element gains the upper hand, while the original motif out of which the picture came into being (the Deluge) is dissolved and transformed into an internal, purely pictorial, independent, and objective existence."

From Kandinsky's lengthy description of the genesis of the painting, it is clear that he leaves no element of the composition to chance. He takes delight even in the tortuous task of balancing the individual elements one against the other, precisely calculating their weights according to a "hidden law" – something he finds no less fascinating than the initial piling-up of masses on the canvas.

Composition VI (p. 92), a huge canvas measuring almost 2 x 3 metres, formed one of the highlights of Herwarth Walden's First German Autumn Salon, which opened on 20 September 1913 in the Sturm gallery in Berlin. The exhibition also included Franz Marc's *The Tower of Blue Horses* (now lost), *Tyrol* and *Animal Destinies*, and August Macke's *Zoological Garden, Four Girls* and *Girls Bathing*. An entire room was devoted to graphic works by Paul Klee and Alfred Kubin, and a memorial exhibition was also mounted of paintings by Henri Rousseau, who had died in 1910.

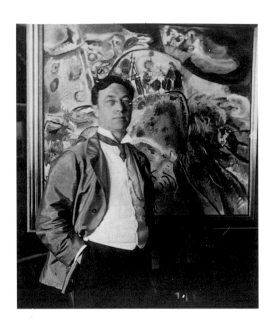

Gabriele Münter:
Kandinsky in Munich in front of
Small Pleasures, c. 1913
Photograph
Munich, Gabriele Münter and Johannes Eichner
Foundation

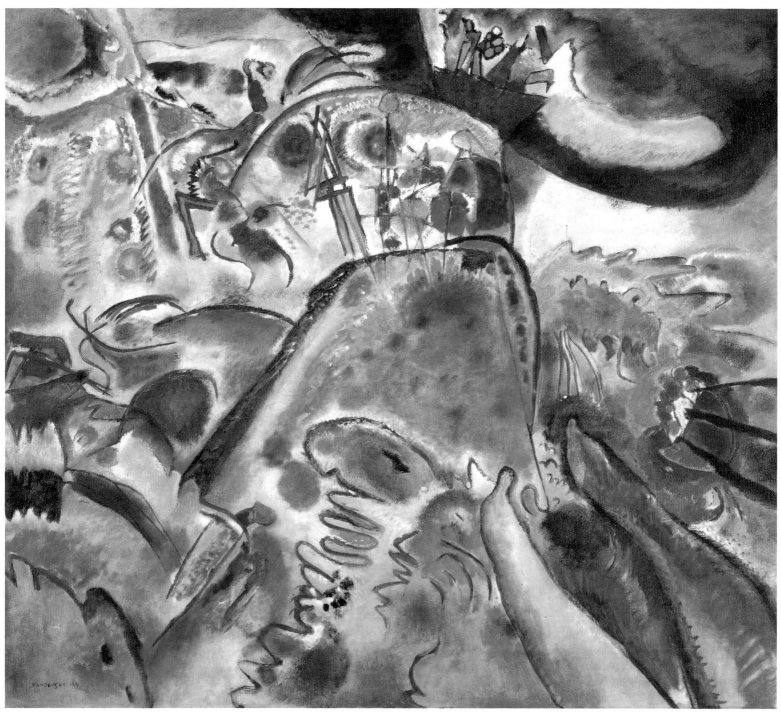

Study for **Small Pleasures**, 1913
Kleine Freuden
Ink, in places over pencil, on grey paper,
24 x 24.7 cm
Munich, Städtische Galerie im Lenbachhaus

Small Pleasures, 1913
Kleine Freuden
Oil on canvas, 109.8 x 119.7 cm
New York, The Solomon R. Guggenheim
Museum

"Based on my *Glass Painting with Sun*… First I
made a drawing, in order to remove the element
of displacement in the large composition and to
make the composition cool and very balanced in
its parts for the picture… I now know that this
was the best starting-point from which to create
the right playground for *Small Pleasures*… The
painting as a whole reminds me of the joyous
sound of small drops falling into water, each one
different."

3 double pages from Kandinsky's book *Sounds* (*Klänge*), 1913
Munich, Städtische Galerie im Lenbachhaus

Between 1908 and 1912 Kandinsky wrote 38 prose-poems, which he illustrated with woodcuts. The abstract poems, which play with sounds rather than meaning, were published in book form by Piper Verlag in 1913, accompanied by the woodcuts.

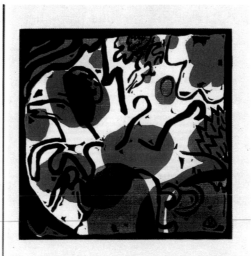

"Kandinsky has undertaken the rarest spiritual experiments in his poems. Out of 'pure existence' he has conjured beauties never previously heard in this world. In these poems, sequences of words and sentences surface in a way that has never happened in poetry before… In a poem by Goethe, the reader is poetically instructed that humankind must die and be transformed. Kandinsky, on the other hand, confronts the reader with a dying and self-transforming image, a dying and self-transforming phrase, a dying and self-transforming dream. In these poems we experience the cycle, the waxing and waning, the transformation of this world. Kandinsky's poems reveal the emptiness of appearances and of reason."
(Jean Arp on *Sounds*).

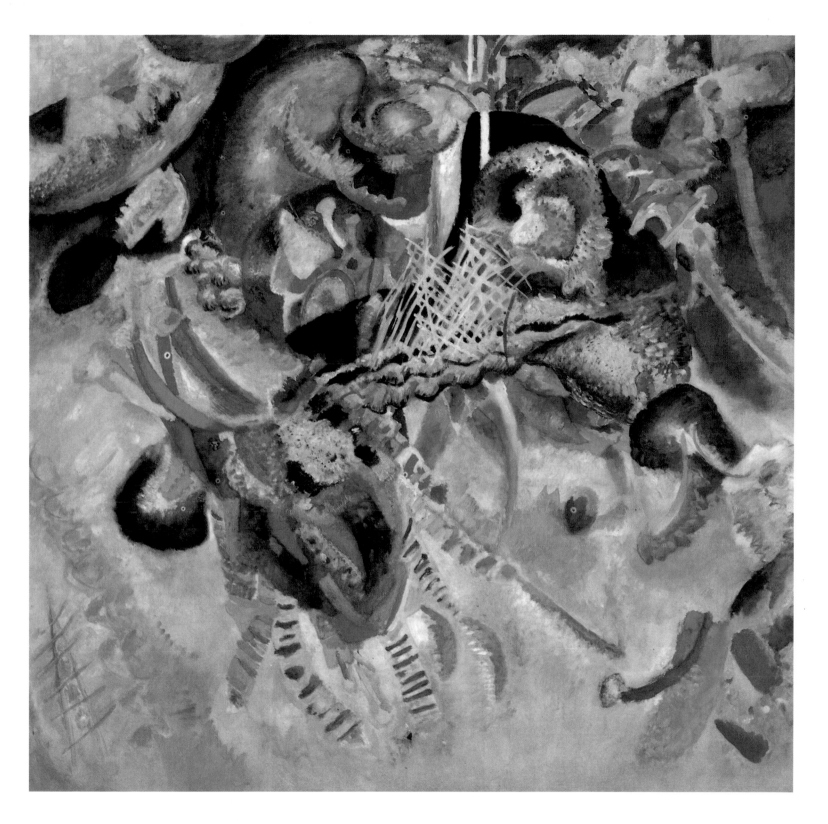

Fugue, 1914
Fuga
Oil on canvas, 129.5 x 129.5 cm
Basle, Collection Ernst Beyeler

Kandinsky believed that painting should take its bearings from music in its search for
rhythm and mathematical construction. He gave the title *Fugue* to this composition
after its completion, in recognition of its "polyphonal order". The lower half of the
picture is a zone of relative calm, with movement increasing towards the middle. "The
network of crisscrossing white lines is like a 'boiling' arising from the collision of the
forces."

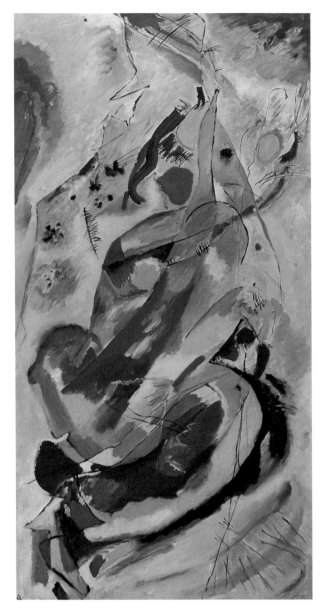
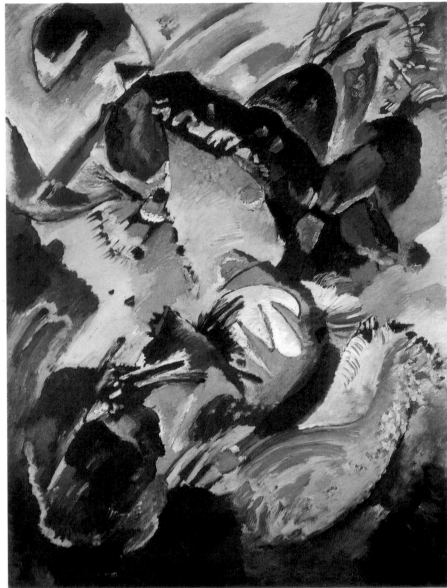

Wall Panel for Edwin R.Campbell, No.1, 1914
Wandbild für Edwin R. Campbell, No.1
Painting Number 200
Oil on canvas, 162.5 x 80 cm
New York, Collection The Museum of Modern
Art, Mrs. Simon Guggenheim Fund

Wall Panel for Edwin R.Campbell, No.2, 1914
Wandbild für Edwin R. Campbell, No.2
Painting Number 201
Oil on canvas, 163 x 123.6 cm
New York, Collection The Museum of Modern
Art, Mrs. Simon Guggenheim Fund

The four wall panels for the American art collec-
tor Edwin R. Campbell, founder of the Chevrolet
motor works, were the last pictures that Kandin-
sky completed before leaving Germany in late
1914. They were destined for the entrance hall of
Campbell's New York apartment, but due to the
war they were not shipped to America until
1916. The commission had been arranged by art
dealer Arthur J. Eddy.

It is in the context of these preliminary studies that we should view
Kandinsky's so-called *First Abstract Watercolour* (p. 107). In its free,
spontaneous style and motival details, this work is so closely related to
the watercolour studies for *Composition VII* that art historians have as-
signed it to the 1913 canvas, despite the fact that Kandinsky himself
dates it to 1910.

Having spent a considerable time developing the idea for *Composi-
tion VII*, Kandinsky finally painted the huge picture within the space of
just a few days, between 25 and 28 November 1913. Gabriele Münter
documented his progress in a series of photographs (p. 108). From
these it is clear that Kandinsky started from the oval form outlined in
black at the centre of the picture and proceeded to cover the canvas
with vibrant and splintered forms. Although he largely follows the pre-
paratory drawing, it is revealing to see how he treats, for example, the
small triangle near the centre of the lower edge. In the preparatory
drawing this can be seen as a fairly distinctive form, but in the final
painting it is almost entirely absorbed into the transparent background
and can only be distinguished by its white aura – a mysterious entity

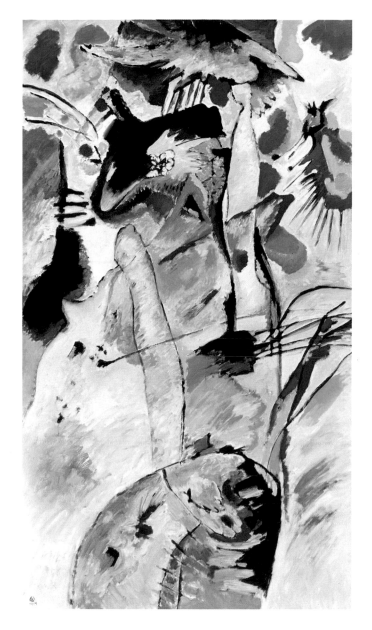

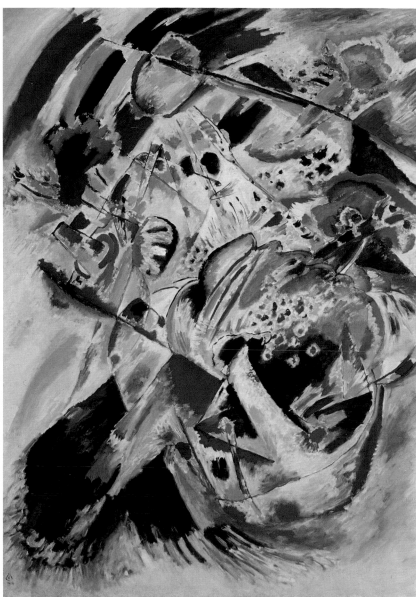

alongside the noisy, powerful colour forms of the surrounding composition.

With a little detective work, *Composition VII* also yields up a number of abbreviated motifs from earlier works: a rowing boat (bottom left-hand corner), a rider (right edge) and a troika (top left-hand corner). These rotate around a seething, exploding centre whose oval graphic form resembles the eye of a Cyclops. "I immersed myself more and more in the manifold value of abstract elements," wrote Kandinsky in his Cologne lecture of 1914. "In this way, abstract forms gained the upper hand and softly but surely crowded out those forms that are of representational origin."

Wall Panel for Edwin R. Campbell, No. 3, 1914
Wandbild für Edwin R. Campbell, No. 3
Painting Number 198
Oil on canvas, 162.5 x 92.1 cm
New York, Collection The Museum of Modern Art, Mrs. Simon Guggenheim Fund

Wall Panel for Edwin R. Campbell, No. 4, 1914
Wandbild für Edwin R. Campbell, No. 4
Painting Number 199
Oil on canvas, 162.3 x 122.8 cm
New York, Collection The Museum of Modern Art, Nelson A. Rockefeller Fund

"… I was glad to get this commission for Herr Kandinsky because it gives him an entrance in New York, and while the price is not large, yet it is quite a venture for my friend to hang four such extremely modern pictures in a place where everybody must see them.
With kindest regards to Herr Kandinsky, I am
Yours very sincerely,
A.J. Eddy"
(Letter to Gabriele Münter, June 1914)

Etching, No. 6, 1916
Radierung, Nr. 6
Drypoint on zinc, printed on copperplate paper,
33 x 25.5 cm
Munich, Städtische Galerie im Lenbachhaus

Kandinsky spent the four months from December 1915 to March 1916 in Stockholm, where he met Gabriele Münter for the last time. During this period he executed grotesque-style watercolours and etchings which he sold through the Gummeson gallery.

Kandinsky and Gabriele Münter in Stockholm,
1916
Photograph
Munich, Gabriele Münter and Johannes Eichner
Foundation

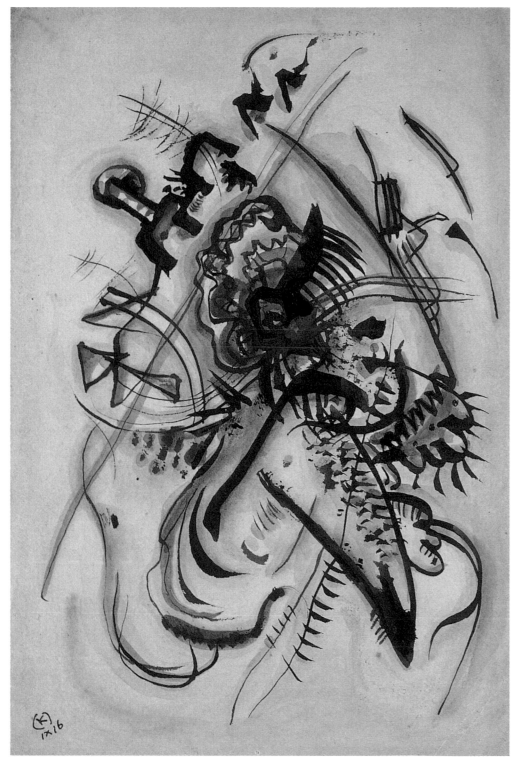

To the Unknown Voice, 1916
Der unbekannten Stimme
Watercolour and ink on paper, 23.7 x 15.8 cm
Paris, Musée National d'Art Moderne,
Centre Georges Pompidou

"Your voice made a great impression on me."
This watercolour arose following Kandinsky's
first – telephone – conversation with Nina, subse-
quently to become his wife, and is dedicated to
her voice. The dense complex of black lines sur-
rounding a central motif is typical of Kandin-
sky's etchings and watercolours of 1916.

Nina Andreevsky before her marriage to
Kandinsky, Moscow, 1913/14
Photograph
Paris, Musée National d'Art Moderne,
Centre Georges Pompidou

Kandinsky's Russian passport photo, 1921
Photograph
Paris, Musée National d'Art Moderne,
Centre Georges Pompidou

"Kandinsky had the noble air of a grand sei-
gneur… I was immediately fascinated by his
kindly, beautiful blue eyes."
(Nina Kandinsky in *Kandinsky and I*)

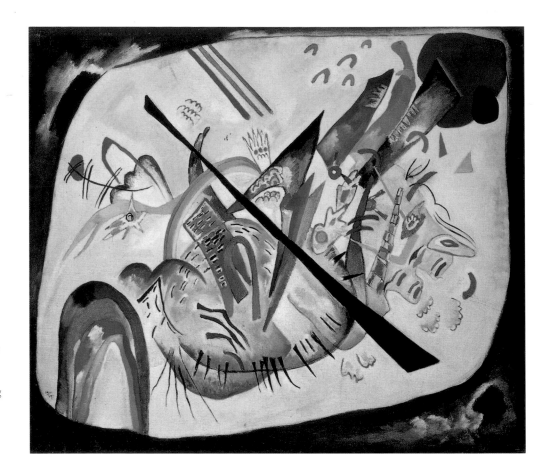

White Oval , 1919
Weißes Oval
Oil on canvas, 80 x 93 cm
Moscow, State Tretyakov Gallery

The framing device which Kandinsky introduces
here for the first time serves to defuse the rigid
rectangularity of the canvas. The internal pictor-
ial elements are now set in an undefined, floating
space. The diagonal orientation of the composi-
tion and the increasing geometrization of forms
into triangles, arches and lines are characteristic
features of Kandinsky's style during this period.

founded the Moscow Institute of Artistic Culture (INKhUK), for whose
curriculum he once again formulated his ideas of a reciprocal relationship
between the arts. Finally, as the head of the state commission for acquisi-
tions, he was also responsible for equipping and opening new museums
in other parts of Russia. Twenty-two such museums were created under
his direction between 1919 and 1921. This enormous workload took up
the greater part of Kandinsky's time.

Kandinsky's artistic production during these seven years in Russia is
strikingly heterogeneous. 1916, for example, saw him producing watercol-
ours and etchings with a somewhat coarse flavour and an almost naïve
style (p. 116 left), which were clearly intended to sell. In other works, such
as *Moscow I*, he revisited the more object-related pictorial world of earlier
years. Two other trends also emerge from the works of this Moscow
period: an increasing geometrization and the inclusion of a border. This
latter appears in *White Oval* of 1919 (p. 120), where a black border is
employed as a compositional means of freeing the inner motif from the
rectangular rigidity of the edges of the canvas. The law of gravity and
the orientations of top and bottom are thereby removed, allowing space to
be perceived in a new way. The white plane floats against a black back-
ground, while opposing directional indicators within it suggest a rotational
movement. Forms are sharper and more pointed and are growing ever
closer to geometric shapes. The diagonals found so frequently in Kandin-
sky's work are emphasized by wedge-shaped triangles.

In Grey (p. 118), also painted in 1919, is a complex composition with
no clear directional indicators. It is one of the largest and most thor-
oughly prepared works of this Russian phase. "*In Grey* marks the end of

my 'dramatic' period, i.e. the very thick piling-up of so many forms."
From a preliminary pencil study, it is clear that Kandinsky started from a
composition of representational motifs: steep mountains, sun, boats with
oarsmen, and figures. In the finished oil painting, these have been trans-
lated into abstract hieroglyphs, gyrating and floating against an indefin-
able grey ground. In terms of its density and complexity, *In Grey* may be
compared with *Composition VII* of 1913 (p. 109). But whereas, in the ear-
lier work, shrill colours modelled themselves into bizarre, often angular
forms in an expressive artistic flourish, the large, abstract colour planes
of the Moscow painting create a cooler and more disciplined atmosphere.
In Grey denotes a significant stage in Kandinsky's transition from his ro-
mantically expressive "dramatic" period to the development of an ab-
stract geometric pictorial language.

Kandinsky's theories and works were already well-known in Russia.
Throughout his years in Munich he had remained in regular contact with
Russia and Russian artists; he had exhibited regularly in Moscow from
1900 onwards, and later also in Odessa and St. Petersburg. In 1910 he ac-
cepted an invitation to take part in the first Jack of Diamonds exhibition
in Moscow. The Jack of Diamonds was a group of artists who, having
initially drawn inspiration from Russian folk art, subsequently oriented

Arch and Point, 1923
Bogen und Spitze
Watercolour, ink and pencil on paper,
46.5 x 42 cm
New York, The Solomon R. Guggenheim
Museum

The construction of this picture, which dates
from Kandinsky's early years in Weimar, reveals
a similar diagonal orientation to *White Oval*
(p. 120). Here, however, the directional indica-
tors consist of purely geometric forms. While
Kandinsky never quite let go of all organic and
expressive elements in his Moscow works, he
nevertheless made the important transition to the
geometric style of his Bauhaus years.

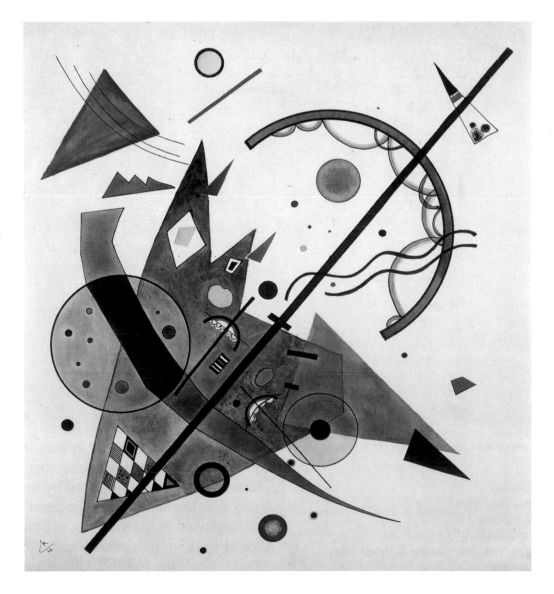

Cup and saucer, decorative design c. 1920
Manufactured by the Petrograd State Porcelain
Factory, 1921
Porcelain, cup 7 cm, saucer 13.8 cm
Private collection

Kandinsky's interest in the applied arts dated
back to Munich, where he had designed bead-
work embroidery and clothes for Gabriele
Münter. He subsequently designed a tea service
for the Petrograd State Porcelain Factory. The
cup and saucer carry abstract motifs from the
paintings of his Moscow years.

joyed in 1912. The point is capable of "altering its outer shape, whereby
it can change from the purely mathematical form of a larger or smaller
circle to forms of unlimited versatility and variability, far removed from
any schematism."

Formal schematism was precisely the danger which Kandinsky be-
lieved accompanied the use of strict geometric forms such as those
preferred by the Russian avant-garde. It is true that Suprematism exerted
a decisive influence upon the development of Kandinsky's art between
1919 and 1921, as can be seen in his adoption of diagonality and the illu-
sion of movement, of geometric figures and their inherent energies, and
of an unhierarchic manner of composition. There is nevertheless a fun-
damental difference between Kandinsky's art and that of his Suprematist
compatriots. Whereas the Suprematists gave priority to the construction
of a picture, employing radically streamlined elements and materials, pre-
cise analysis and conscious design, Kandinsky saw the expressive, true
essence of the picture solely in its composition, namely the free combina-
tion of manifold pictorial elements.

Kandinsky's ideas brought him into conflict with his Constructivist col-
leagues at INKhUK, Moscow's Institute for Artistic Culture. The Con-
structivists banned all subjective and atmospheric elements from their
painting ("It will only be possible to create a science of art when there
are quantifiable, objective characteristics that define the true achieve-
ments in the field of art"), and therefore rejected Kandinsky's art as "har-
monious" and "painterly", as "spiritualistic malformations".

Meanwhile, the political situation in Russia was making it increasingly
difficult to pursue an independent artistic career. The pressure on artists
to place their work in the service of Marxist-Leninist ideology was in-
creasing. In 1921 the Communist Party announced its new economic pol-
icy, as part of which art, literature, film and theatre were to be employed
for propaganda purposes. Abstract art was branded damaging and sub-
versive. The ground for socialist realism was now prepared. Kandinsky
was denigrated as a "bourgeois iconoclast", a "typical metaphysician and
individualist in art". When Kandinsky – who always described himself as
non-political and consequently was not a member of the Communist
Party – was passed over for the directorship of the Moscow Academy, the
decision to turn his back on Russia edged another step closer.

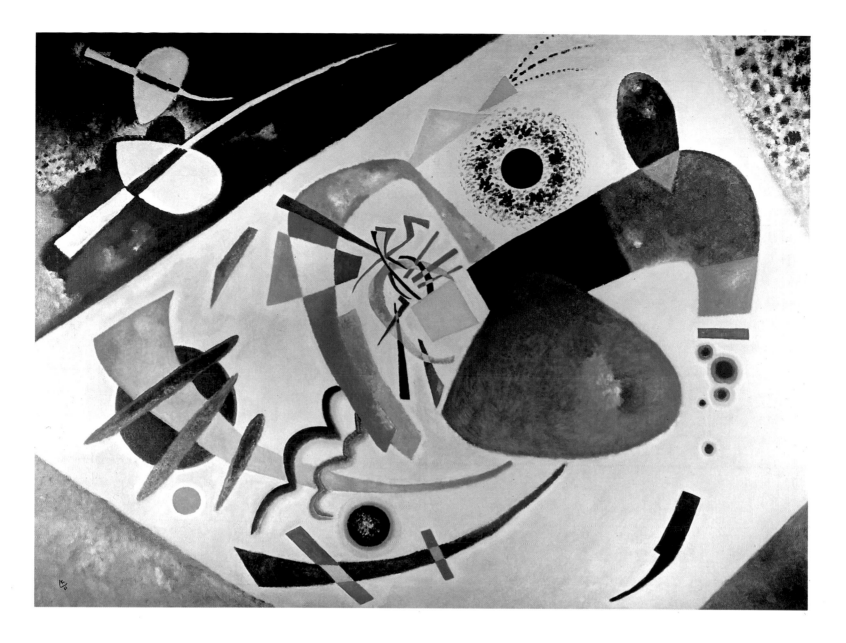

Red Spot II, 1921
Roter Fleck II
Oil on canvas, 131 x 181 cm
Munich, Städtische Galerie im Lenbachhaus

A pale trapezoid is angled across the foreground in such a way that its corners are cut
off by the edges of the canvas, propelling it into a rotational movement. This plane
provides the backdrop for a dynamic interplay of freely-invented pictorial forms,
whereby the red spot assumes the dominant role. Red, according to Kandinsky, is
"burning and glowing", an "immense, almost purposeful strength". A new geometric
element also appears here for the first time: the circle, a form which would assume
elemental significance for Kandinsky at the Bauhaus.

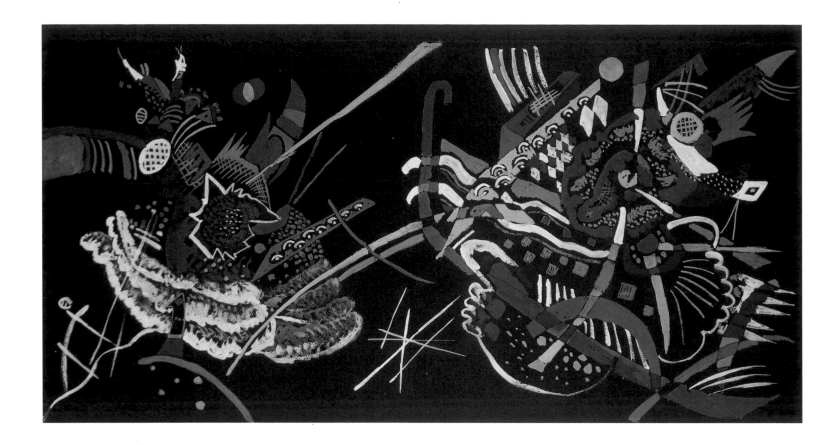

Design for a mural in the Unjuried Art Show:
Wall A, 1922
Wand A
Gouache and white chalk on black paper,
mounted on card, 34.7 x 60 cm
Paris, Musée National d'Art Moderne,
Centre Georges Pompidou

the commonplace. Art must push forward. Mere explosions in art are ultimately boring."

In view of his thinking on art, Kandinsky seems almost predestined for a career at the Bauhaus. His gift for teaching, together with his artistic theories – developed further in Moscow – aiming at a synthesis of all the arts, made him an appropriate teacher for a modern-style establishment such as the Bauhaus, which rejected traditional Academy methods of art education in favour of theoretical and practical training in a wide range of artistic skills.

The reforms being pioneered in art education by such craft-oriented schools as the Bauhaus had their origins in the second half of the 19th century, when the desire to marry industry and art gave birth to the Arts and Crafts movement in England. This movement was taken up in Germany at the start of the 20th century with the founding of the Deutscher Werkbund (German Work Federation), a joint venture between art and industry. Companies affiliated to the Werkbund were encouraged to employ artists to design their products, with the scope of commissions ranging from household utensils to architecture. Following the First World War, the Weimar Republic then brought forth a generation of artists' associations who argued that the arts should be adapted to the needs of the new "socialist society". These included the Arbeitsrat für Kunst (Art Soviet) and the Novembergruppe (November Group), as well as the Bauhaus in Weimar.

The State Bauhaus in Weimar was founded in 1919 by the architect Walter Gropius. It represented the amalgamation of the former Academy of Fine Art and the former School of Arts and Crafts (previously headed, until 1914, by Henry van de Velde). Its foundation took place in a period of revolutionary unrest and political confusion as to where administrative au-

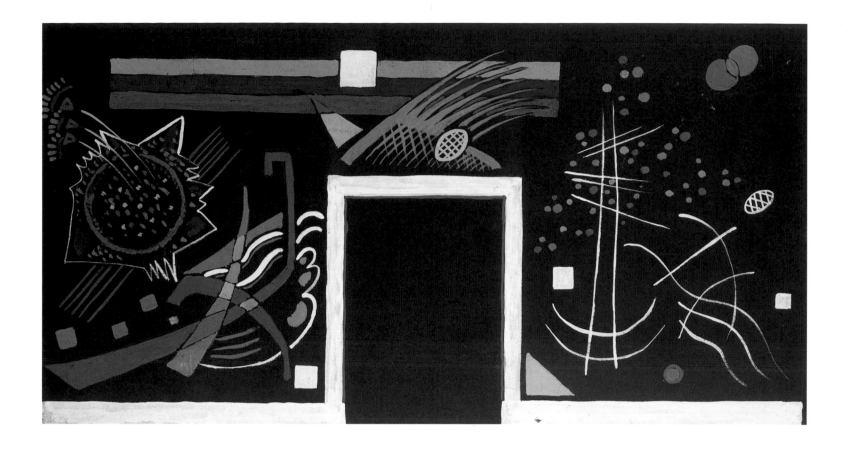

Design for a mural in the Unjuried Art Show:
Wall B, 1922
Wand B
Gouache and white chalk on black paper,
mounted on card, 34.7 x 60 cm
Paris, Musée National d'Art Moderne,
Centre Georges Pompidou

thority for the new school actually lay. Had the situation been otherwise, however, such a progressive institution would never have been approved. And indeed, as the conservative forces regrouped over the ensuing months and years, the Bauhaus' existence became increasingly threatened.

In April 1919 Gropius published the first *Bauhaus Manifesto*, in which he declared the aim of the Bauhaus to be the union of all the arts under the primacy of architecture: "The ultimate aim of all creative activity is the building!... Architects, painters and sculptors must learn again to know and comprehend the multi-faceted structure of the building in its entirety and in its parts. Only then will their works fill themselves again of their own accord with the architectonic spirit which has been lost in salon art... There is no essential difference between the artist and the craftsman... Craftsmanship is the imperative foundation for every artist; it is the source of creative invention. Let us desire, conceive and create together the new building of the future, comprising everything in one form – architecture and sculpture and painting..."

The *Bauhaus Manifesto*, which was rapidly publicized throughout Germany, was accompanied by an educational programme in which Gropius sought to combine artistic and theoretical elements with practical and technical skills. The artist was once again to become a craftsman in the original sense of the word. The choice of the name Bauhaus (lit. "Building House") is itself significant in this respect: it evokes associations in German with the medieval *Bauhütten*, the guilds of artisans involved in the building of a cathedral. Conventional art teaching needed to be changed, even revolutionized: specialization and dogmatic academic tradition were to be thrown out of the window. The teachers were called not professors but "masters" (although the title "professor" was reintro-

Kandinsky was able to realize his dream of uniting painting and architecture in these designs for monumental murals for the entrance hall of a museum of modern art – even if the project was never actually executed. The paintings, which line the entire room, aroused in him the same feeling that had overwhelmed him as a student upon encountering the richly decorated houses in Vologda province:
"In these magical houses I experienced something I have never encountered again since. They taught me to *move within the picture*, to live in the picture."

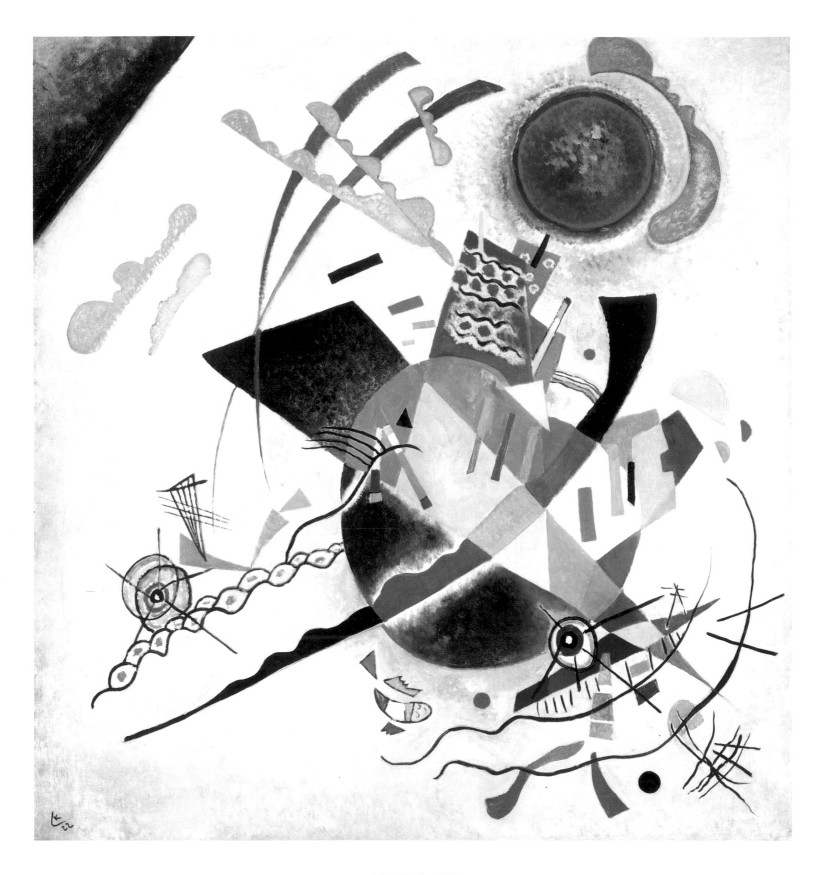

Blue Circle, 1922
Blauer Kreis
Oil on canvas, 110 x 100 cm
New York, The Solomon R. Guggenheim Museum

In the six months that Kandinsky spent in Berlin before taking up his appointment in
Weimar, he painted only two pictures. One was *Blue Circle*. The composition consists
of geometrizing and organic-seeming elements which appear to rotate in a centrifugal
movement around the centre.

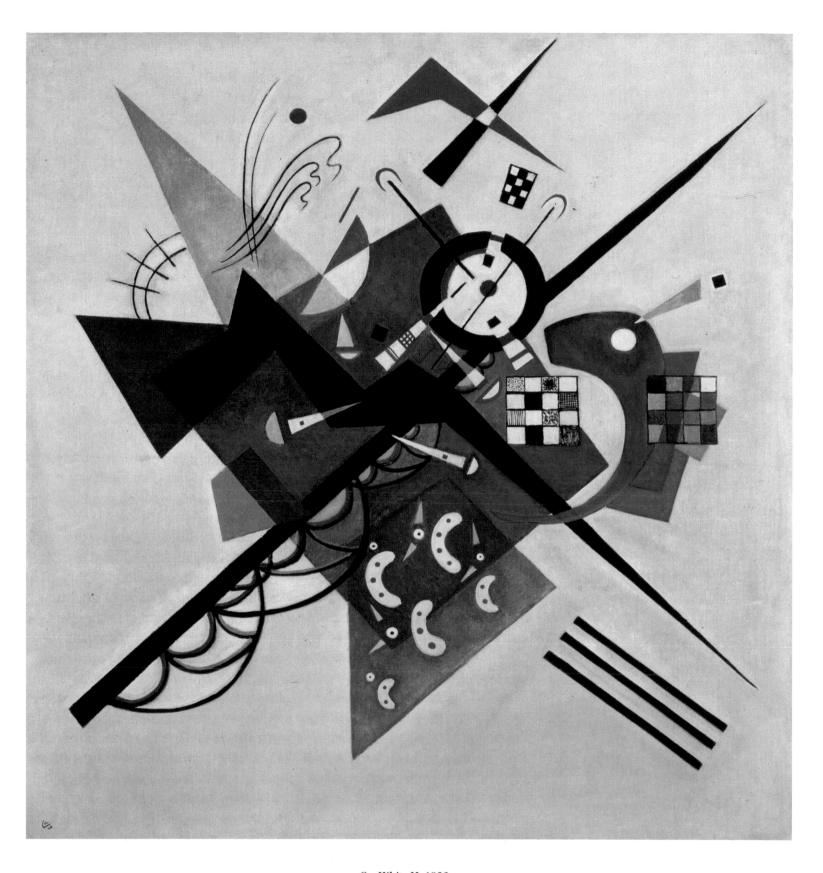

On White II, 1923
Auf Weiß II
Oil on canvas, 105 x 98 cm
Paris, Musée National d'Art Moderne, Centre Georges Pompidou

A disciplined, almost square composition whose corners are accentuated by intersect-
ing diagonals. Kandinsky's forms are growing ever clearer and more geometric. The
independent undulating lines seen a year earlier in *Blue Circle* have now become rigid
parallel bars (bottom right-hand corner). The white ground provides a neutral back-
drop against which the black lines and coloured planes explode.

Indeed, the correspondences between colours and forms and the systematic study of individual elements were amongst Kandinsky's chief preoccupations at the Bauhaus. Alongside his activities in the mural-painting workshop, Kandinsky – like his colleague Paul Klee – also ran a course on the theory of form as part of the *Vorkurs*, as well as offering a class on analytic drawing.

Kandinsky devoted particular attention in his classes to the relationship between colour and form. He believed that certain colours correspond to certain forms, i.e., that certain forms heighten the impact of certain colours. In order to test his theory, he drew up a questionnaire which he issued to the students in his mural-painting workshop. The students were asked to fill in the three elementary forms of triangle, square and circle in the primary colour they felt suited it most. By far the largest number coloured the triangle yellow, the square red and the circle blue, thereby confirming Kandinsky's own conclusions (p. 144 above). The next step was to find geometric forms corresponding to the secondary colours of green, orange and violet, a task which Kandinsky set his pupils in the classroom. Forerunners of these experiments can be seen in Suprematist works by Malevich and Rodchenko, in which overlapping geometric forms in contrasting colours serve to illustrate spatial relationships and principles of tension.

Kandinsky had already introduced the idea of interaction between colour and form in *On the Spiritual in Art*: in view of our synaesthetic association of "yellow" with "sharp", he believed, the effect of yellow is emphasized when combined with a sharp form. Similarly, the effect of a deeper colour such as blue is reinforced by rounded forms.

Kandinsky applied these colour theories to his art throughout his years at the Bauhaus. A particularly revealing example is *Yellow-Red-Blue* of 1925 (p. 145). Here, as the title suggests, the main emphasis falls on the three primary colours, and notably on the opposition between yellow and blue. The left-hand side of the picture appears bright, light and open; its dominant yellow is accompanied by delicate black lines and framed by a cloud-like violet-blue border. By contrast, the right half of the composition, with its large blue circle set against a pale yellow ground, appears dark, heavy and dramatic. These two contrasting halves are linked by the red colour planes and the grey quadrilateral at the centre of the canvas. The black-and-white chequered form inside the grey quadrilateral takes up both the blacks of the right-hand, blue half (whiplash line, small circle, diagonal) and the whites of the left-hand, yellow half (set of white semicircles on a black line). Kandinsky thereby links and simultaneously accentuates the polarities within the composition. *Yellow-Red-Blue* is thus an example of opposition and mediation, of the abstract representation of elementary contrasts. In its rich palette and formal variety it is closer to *Unbroken Line* than to the rigidly-organized *Composition VIII*, whereby its atmospheric background gives it an additional intensity.

Kandinsky painted *Yellow-Red-Blue* during the school's last few months in Weimar, shortly before it moved to Dessau. Having been the regular target of criticism from conservative right-wing forces ever since its foundation, the Bauhaus was now suspected of nurturing Communist intrigues, placing its existence under growing threat. When the Thuringian regional

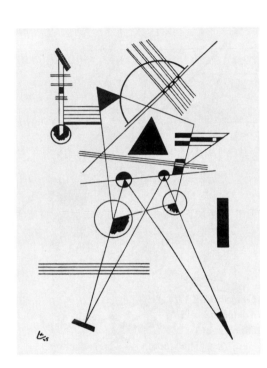

Inner Relationship between Complex of Straight Lines and Curve (left-right), 1925
Innere Beziehung eines Komplexes von Geraden zu einer Gebogenen
Drawing accompanying the painting *Black Triangle*

This drawing appears in Kandinsky's book *Point and Line to Plane* of 1925 and was therefore probably made after the oil painting itself. Diagrammatic drawings of this kind expose the most important linear structures within a pictorial composition and thus emphasize the constructive dimension of the paintings they accompany.

PAGE 143:
Black Triangle, 1925
Schwarzes Dreieck
Oil on card, 79 x 53.5 cm
Rotterdam, Collection Museum Boymans-van-Beuningen

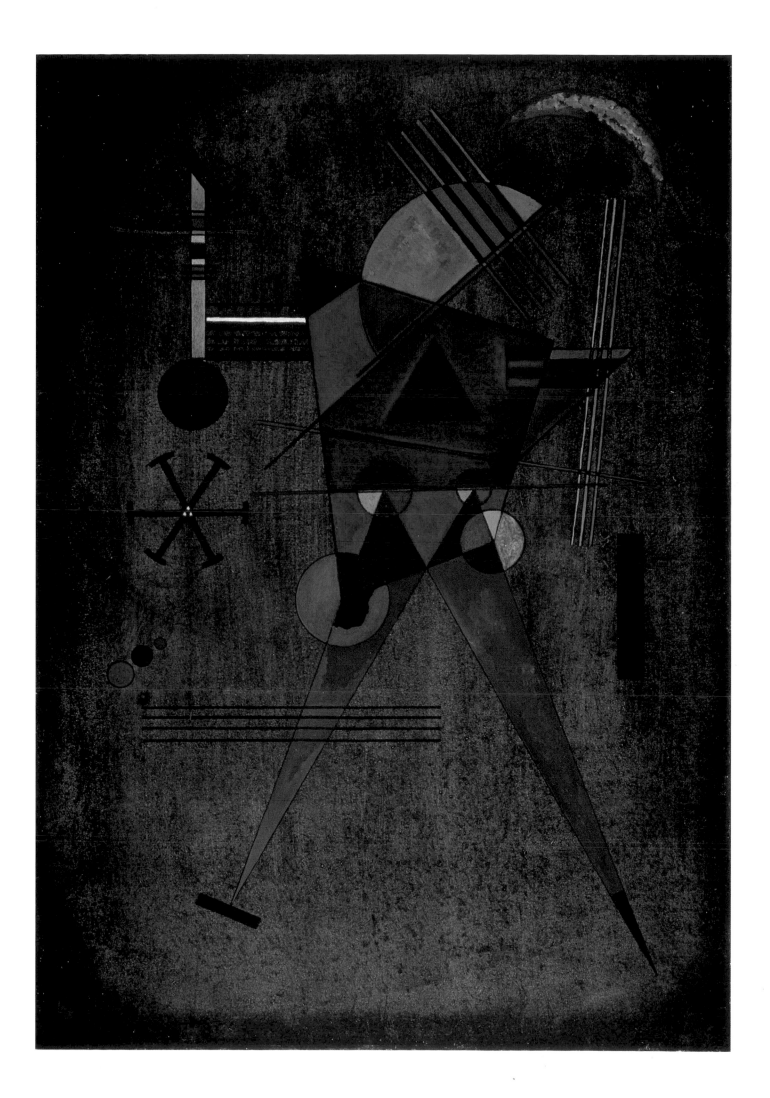

Lucia Moholy:
Wassily and Nina Kandinsky in the dining room
of their Master's house in Dessau, 1926
Photograph
Berlin, Bauhaus-Archiv

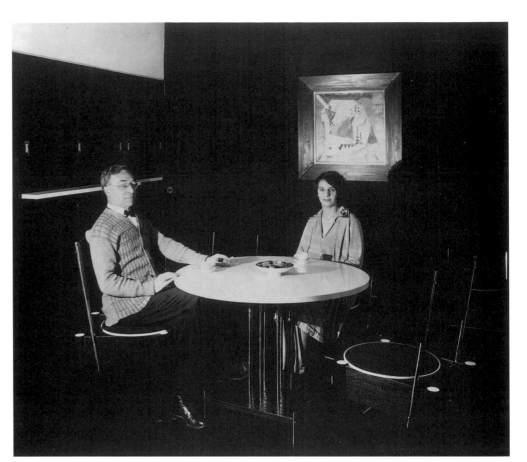

ABOVE LEFT:
Marcel Breuer:
Chair for Kandinsky's dining room in Dessau
(based on designs by Kandinsky), 1926
Wood, painted black and white, nickel-plated
metal and black fabric
Paris, Musée National d'Art Moderne,
Centre Georges Pompidou

BELOW LEFT:
Marcel Breuer:
Tubular-steel chair, 1925/26
Nickel-plated steel and Eisengarn fabric
Berlin, Bauhaus-Archiv

Masters' houses, Dessau, 1926
Photograph
Paris, Musée National d'Art Moderne,
Centre Georges Pompidou

The Masters' houses at the Dessau Bauhaus were
designed by Walter Gropius, who saw them as
experimental examples of the lifestyle of the fu-
ture. They were intended to illustrate "modern
living" right down to their finest details and to
demonstrate the harmony of technical function-
ality and aesthetic extravagance.

PAGE 146, BELOW RIGHT:
View of the niche, partially decorated with gold
leaf, in Kandinsky's Dessau living room, c. 1928
Photograph
Paris, Musée National d'Art Moderne,
Centre Georges Pompidou

rules. These rules are not determined by the artist at will, but are laws
which arise from the compositional elements themselves and their im-
manent energies.

The first object of Kandinsky's investigation is the point, which for
him forms the primordial element of painting, and which he submits to a
microscopic analysis.

He examines the various outer forms that a point can assume as soon
as it has overstepped its ideally small form, namely that of a circle
(p. 148, below left). The point can assume an infinite variety of appear-
ances; it may tend towards geometric forms or towards free forms. "It is
impossible to determine any limits, for the realm of the point is limit-
less." The external form and size of the point thereby determine its
"basic sound".

The "multiplicity and complexity of expression in the case of the
'tiniest' form – achieved by only minimal variations in size – offer even
the non-specialist a convincing example of the expressive power and ex-
pressive depth of abstract forms."

A circular point, for example, has a concentric tension and displays no
inclination to move in any direction. "This lack of any impulse to move

the point, the line and the plane and their immanent energies. Klee also started from these elements in his *Pedagogical Sketchbook (Pädagogisches Skizzenbuch)*, published as Bauhaus book no. 2, but saw in everything a principle of movement, of growing and becoming. Despite their contrasting ideas, Klee and Kandinsky sometimes produced astonishingly similar pictures during their time together in Dessau (cf. pp. 158/159). When Klee left the Bauhaus in 1930 to go and teach at the Düsseldorf Academy of Art, Kandinsky wrote a farewell tribute to him which was published in *bauhaus* no. 3 (printed in lower case, as was usual for Bauhaus typography): "as an example of unswerving dedication to his work, we could all learn something from klee. and undoubtedly have learned… at the bauhaus, klee exuded a healthy, generative atmosphere – as a great artist and as a lucid, pure human being."

During his time at the Bauhaus, Kandinsky was also offered the opportunity to turn his ideas of a synthesis of the arts into reality in a stage production at Dessau's Friedrich Theatre. Although the Bauhaus had its own theatre workshop, Kandinsky's connections with it were few. Theatre at the Bauhaus was largely dominated by the figure of Oskar Schlemmer, who had begun his Bauhaus career as a student in the joinery workshop and in 1925 had taken over the theatre workshop. Schlemmer subscribed to the "elemental" approach practised at the Bauhaus, breaking down his theatre work into the basic elements of space, form, colour, sound, movement and light. Building upon these basic elements, Schlemmer de-

Paul Klee:
Senecio, 1922
Oil on gauze on card, 40.5 x 38 cm
Basle, Öffentliche Kunstsammlung Basel,
Kunstmuseum

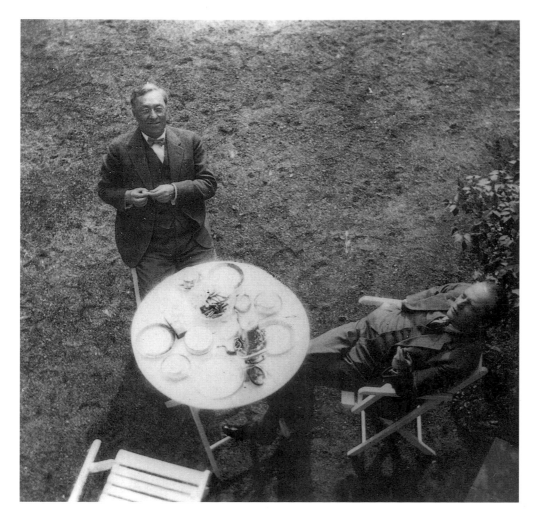

Kandinsky and Klee photographed from the balcony, Dessau, 1930
Photograph
Paris, Musée National d'Art Moderne,
Centre Georges Pompidou

Klee and Kandinsky occasionally produced astonishingly similar pictures during their time together in Dessau. Whereas Kandinsky's paintings were abstract formations which allowed figurative associations, Klee's were abstracted forms harbouring poetic significance. Both men published their theories on art as part of the series of Bauhaus books; Klee's *Pedagogical Sketchbook* appeared in 1925 and Kandinsky's *Point and Line to Plane* in 1926.

PAGE 158:
Upward, 1929
Empor
Oil on card, 70 x 49 cm
Venice, The Peggy Guggenheim Collection

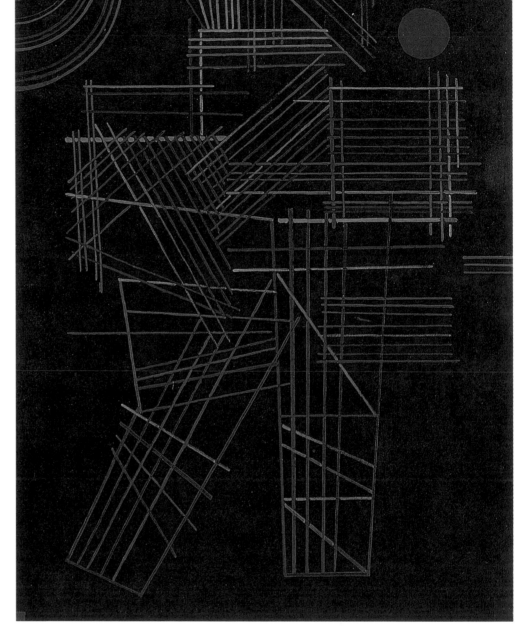

Paul Klee:
Gate in the Garden, 1926
Tor im Garten
Oil on card, 54.5 x 44 cm
Berne, Kunstmuseum Bern,
Prof. Max Huggler Foundation

Colourful Sticks, 1928
Bunte Stäbchen
Mixed media on card, 42.7 x 32.7 cm
New York, The Solomon R. Guggenheim
Museum, Gift of Solomon R. Guggenheim, 1938

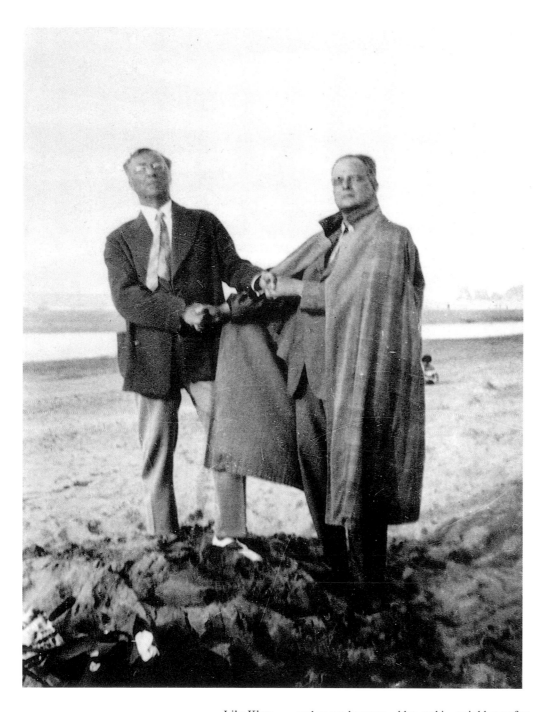

Lily Klee:
Kandinsky and Klee Imitating the Goethe and
Schiller Monument in Weimar, 1929
Paris, Musée National d'Art Moderne,
Centre Georges Pompidou

"more than twenty years ago, i moved into the
ainmillerstraße in munich, and soon learned that
the young painter, paul klee, who had just made
his successful debut at the galerie thannhauser,
lived almost next door to me. we remained neigh-
bours up until the outbreak of the war, and from
this period dates the beginning of our friendship.
we were blown apart by war. only eight years
later did fate bring me to the bauhaus at weimar,

and so we became – klee and i – neighbours for
a second time: our studios at the bauhaus were
situated almost side by side. soon followed an-
other separation: the bauhaus flew from weimar
with a rapidity that a zeppelin might have en-
vied. to this flight klee and i owe our third and
closest period of proximity: for more than five
years we have been living right next to one an-
other, our apartments separated only by a fire-
proof wall. but despite the wall, we can visit one
another without leaving the building, by a short
walk through the cellar… but our spiritual
proximity would have existed even without ac-
cess through the cellar."
(Kandinsky's tribute to Klee upon the latter's
departure from the Bauhaus, 1931)

Lily Klee:
The Goethe and Schiller Monument in Weimar,
1929
Photograph
Paris, Musée National d'Art Moderne,
Centre Georges Pompidou

Fixed Flight, 1932
Fixierter Flug
Oil on panel, 49 x 70 cm
Paris, Collection M. and Mme. Maeght

The free distribution of small, component-like forms within an undefined pictorial space anticipates elements of Kandinsky's later Paris works.

course for the Bauhaus," the students declared, "the primary task of the *Vorkurs* should be to provide students with a historico-theoretical introduction to the development of the social and material fundamentals and of the intellectual cohesion which follows from these, and on this basis develop the future tasks of the Bauhaus."

There were calls for the abolition of the *Vorkurs*, for classes by Albers and Kandinsky to be made optional, and for the introduction of the "historico-theoretical" teaching on a social and materialistic basis already mentioned in the proclamation.

Such a development was fatal for the Bauhaus, whose contract with the city of Dessau precluded it from all political activity. Hesse, Dessau's mayor, demanded Hannes Meyer's resignation. Meyer was succeeded by the architect Ludwig Mies van der Rohe, who took over as head of the Bauhaus in summer 1930.

Meanwhile, Kandinsky prepared his theoretical course on artistic design for the last time. In Dessau, as in Weimar, he constantly sought to broaden his teaching by including new materials and design examples. He now incorporated scientific material from the fields of botany, zoology, astrology and crystallography into his course.

In 1931 Kandinsky received one final opportunity to decorate an interior, when he was commissioned to execute three large-scale compositions,

made out of ceramic tiles, for the walls of a music room. This music room was to form part of the German Architecture Exhibition ("Bau-Aus-stellung") in Berlin, where it appeared in the section entitled "The Modern Apartment", organized by Mies van der Rohe. In these ceramic designs Kandinsky took up the geometric forms and abstract structures of his late Dessau works. A room in which people gather to experience music, Kandinsky wrote in the catalogue to the exhibition, must have a special power. Painting, which serves as a kind of tuning fork, can affect people and "tune" them for such a musical experience. With the help of the ceramics company Villeroy and Boch, Kandinsky's music room was reconstructed in 1975 at Artcurial in Paris, where it can still be seen.

Political developments in Germany at the end of the 1920s once again posed an acute threat to the Bauhaus' existence. Boosted by the results of the Reichstag elections in September 1930, the National Socialists stepped up their campaign against the Bauhaus. The Dessau National Socialists demanded the school's immediate closure: "Foreign members of staff must be dismissed without notice, since it is incompatible with the responsibility that a good municipal government bears towards its cit-

Decisive Pink, 1932
Entscheidendes Rosa
Oil on canvas, 80.9 x 100 cm
New York, The Solomon R. Guggenheim Museum

Striking here is the even distribution and strictly vertical and horizontal alignment of the geometric forms.

Division – Unity, 1934
Division – Unité
Mixed media on canvas, 70 x 70 cm
Tokyo, Museum of Modern Art

A relaxed complex of freely-invented formations
in which Kandinsky gives his imagination full
rein. The artist invents a range of cheerful pictor-
ial symbols as if compiling a sheet of design
samples.

coussis, thoroughly versed in the Parisian art scene, the Jeu de Paume mu-
seum agreed to stage the exhibition "Origines et Développement de l'Art
International Indépendant", tracing the development of modern art from
Impressionism through to abstraction. The response was highly favour-
able. For the first time, Kandinsky's pictures were seen by a large public.

Kandinsky was virtually only able to show paintings from the last de-
cade, however. The large and innovative œuvre of his Moscow and Bau-
haus years was scattered between the United States and Russia (which in
1930 had confiscated the paintings he had deposited in Moscow), while
many of his Munich works, and especially those of his Blaue Reiter
period, were still in the care of Gabriele Münter. As a consequence, much
of his work was not accessible to the public and in many cases had not
even been photographed. In the Paris exhibition of 1937, Kandinsky was
only able to include *Picture with a Black Arch* (p. 88) of 1912 from his
Munich period, and *On White II* (p. 139) of 1923 from his Bauhaus
period. It was clearly difficult for him to provide a true summary of his
life's work, and it is understandable that he should press Christian
Zervos, who in 1929 had published a monograph on Paul Klee, to do the
same for him.

For Kandinsky and his wife, both German citizens since 1928, the situ-
ation in Paris grew increasingly awkward towards the end of the 1930s.
When their German passports ran out and they had supply proof of their

Kandinsky in his studio in Neuilly-sur-Seine,
c. 1937, Photograph
Paris, Musée National d'Art Moderne,
Centre Georges Pompidou

Untitled, 1934
Chinese ink on paper, 33.1 x 22.8 cm
Paris, Musée National d'Art Moderne,
Centre Georges Pompidou

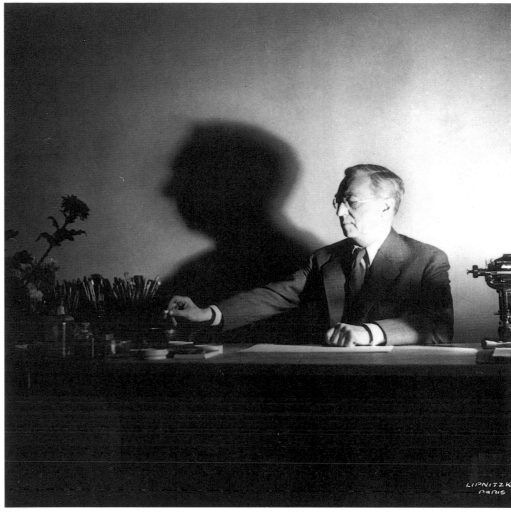

Thirty, 1937
Trente
Oil on canvas, 81 x 100 cm
Paris, Musée National d'Art Moderne,
Centre Georges Pompidou

Thirty irregular rectangular fields house thirty
different drawings. The strict alternation of black
and white not only provides a supporting com-
positional framework, but also enables Kandin-
sky to investigate the effect of black forms on
white and white forms on black.

177

Untitled, 1934
Pencil on paper, 19.1 x 14.1 cm
Paris, Musée National d'Art Moderne,
Centre Georges Pompidou

"Our age is not an ideal one, but among the few
important 'innovations', or among mankind's
new qualities, one must know how to appreciate
this growing ability to hear a sound in the midst
of silence... Nowadays, in painting a point some-
times expresses more than a human face."
(Kandinsky in *Reflections on Abstract Art*, 1931)

PAGE 185:
Tender Ascent, 1934
Montée tendre
Oil on canvas, 80.4 x 80.7 cm
New York, The Solomon R. Guggenheim
Museum

tions in Kandinsky's sketches (p. 177 above), here being tested out as
pictorial elements. The invention of a rich formal vocabulary is not
Kandinsky's sole concern, however; he is equally interested in the neg-
ative-positive effects: how do black forms appear on white, and vice
versa? In 1930 he painted *White on Black*, a geometric composition in
which white rectangles are arranged in a concentric rhythm on a black
background. *Thirty* is a more complex picture, but also more schem-
atic. It seems as if the artist, well aware that an uncontrolled handling
of pictorial elements can lead to arbitrariness, wanted to avoid this
danger by weaving his forms into a structural framework.

In 1939 Kandinsky painted his tenth and last great *Composition*
(p. 186). Here a bubblelike and a trapezoidal form are set against a dark
ground, while small forms float around them. The two main figures seem
to have broken out of their geometric existence and to have transformed
themselves into organic formations, which are moving upwards and away
from each other. Some of the small forms are arranged in convex waves,
emphasizing the upward movement of the trapezoidal form. By contrast,
a similar but concave wave in the lower half acts as a stay. The left-hand,
bubblelike form is pushed outwards and away from the trapezoidal form
by its accompanying smaller forms. The rows of small ciphers contained
within it are suggestive of characters and cite the hieroglyphic formations
from the earlier *Rows of Signs* of 1931 (p. 164).

Despite the diversity of its forms, *Composition X* is an example of
unity and harmony and represents one of the most magnificent works of
Kandinsky's Paris years. The composition is balanced, and both cool and
warm colours assume equal luminosity against the dark ground. The free-
floating forms evoke the image of cosmic constellations which are sub-
ject to inner laws of harmony.

In *Around the Circle* (p. 187), painted one year later, fantastical forms
float in "musical" movements around the red circle of the title. Here, too,
the dark ground makes the colours stand out all the more strongly, with
the glowing red circle, reinforced by pink, striking the dominant note.
"Red, as one imagines it," wrote Kandinsky in *On the Spiritual in Art*,
"is a limitless, characteristically warm colour, with the inner effect of a
highly lively, living, turbulent colour, yet which lacks the rather light-
minded character of yellow, dissipating itself in every direction, but
rather reveals, for all its energy and intensity, a powerful note of im-
mense, almost purposeful strength. In this burning, glowing character,
which is principally within itself and very little directed toward the exter-
nal, we find, so to speak, a kind of masculine maturity..."

Kandinsky's pictures of these years give no hint of external events, of
the war and the German Occupation. Daily life was seriously affected:
fuel and food were both in short supply; it was almost impossible to trans-
fer money; deliveries of mail were rare; and there were no magazines at
all. Materials for painting were equally difficult to procure. Despite this,
Kandinsky tried to live life as normal. He continued to attend the few ex-
hibitions that were held in Paris. In 1942, an exhibition of his own works
was staged by the courageous gallery-owner Jeanne Bucher under the dif-
ficult conditions of the Occupation. In summer 1942 he painted his last
large-format picture, after which he restricted himself to small formats on

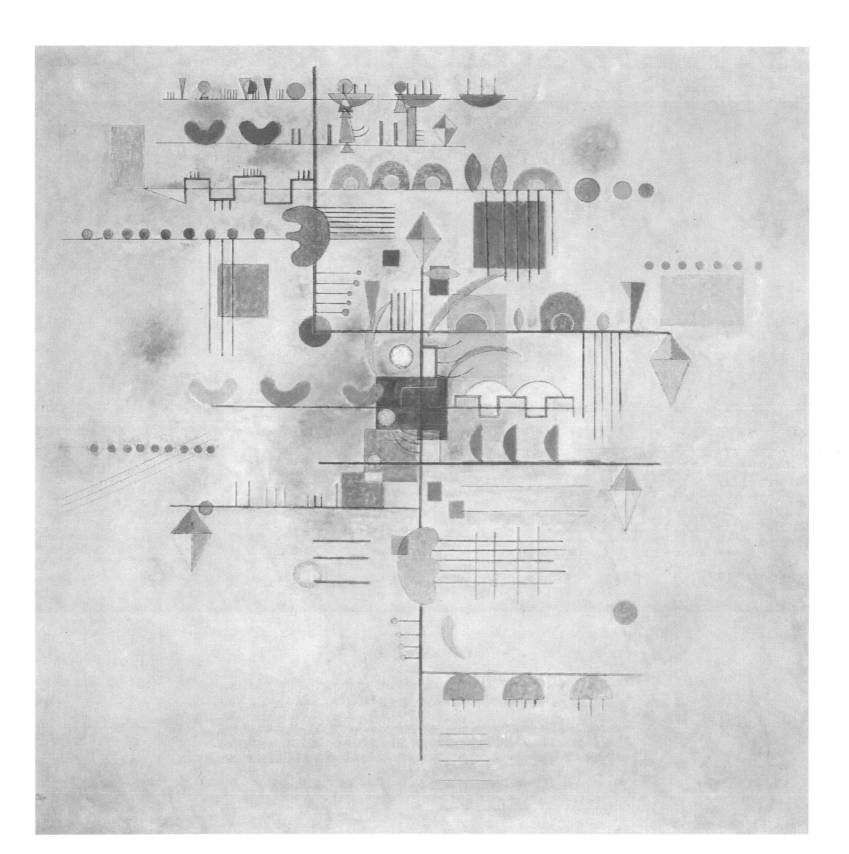

The publishers wish to thank the museums, archives and photographers for their permission to reproduce the illustrations and for their support and encouragement in the preparation of this book. We are particularly grateful to the Städtische Galerie im Lenbachhaus, Munich, the Musée National d'Art Moderne, Paris, and the Solomon R. Guggenheim Museum, New York. In addition to the collections and institutes named in the captions, the following acknowledgements are also due:
Archiv für Kunst und Geschichte, Berlin: 20, 48, 76, 178;
Artothek, Peissenberg: 58;
Bauhaus-Archiv, Berlin: 195;
H. Bayer, Berlin: 149;
Erik Bohr, Berlin: 132;
Martin Bühler, Berlin: 159, 164;
Photograph courtesy of The Art Institute of Chicago, Chicago: 103;
David Heald, copyright The Solomon R. Guggenheim Foundation, New York: 35, 37, 82, 99, 102, 121, 138, 154, 156, 160, 165, 167, 169, 172, 183, 188, 190;
Photograph, © 1991 The Solomon R. Guggenheim Foundation, New York: 158;
Bildarchiv Hansmann, Munich: 12, 28;
Lepkowski, Berlin: 144, 146;
Musée National d'Art Moderne, Centre Georges Pompidou, Paris: 196;
Museum Folkwang, Essen: 178;
Photograph, © 1993, The Museum of Modern Art, New York: 112, 113, 168;
Schneider, Berlin: 140;
Elke Walford, Hamburg: 47